MW01259478

Emily Botelho, who works under the name Salt Stitches, formerly had a career in the fashion industry and turned to embroidery in 2018. She has built a substantial following, sharing and selling her hoop-based works on Instagram and via her website www.saltstitches.com. She teaches workshops all over the world, including the UK, US and Spain. In 2021, Emily emigrated to Canada where she stitches full time.

Abstract
Embroidery

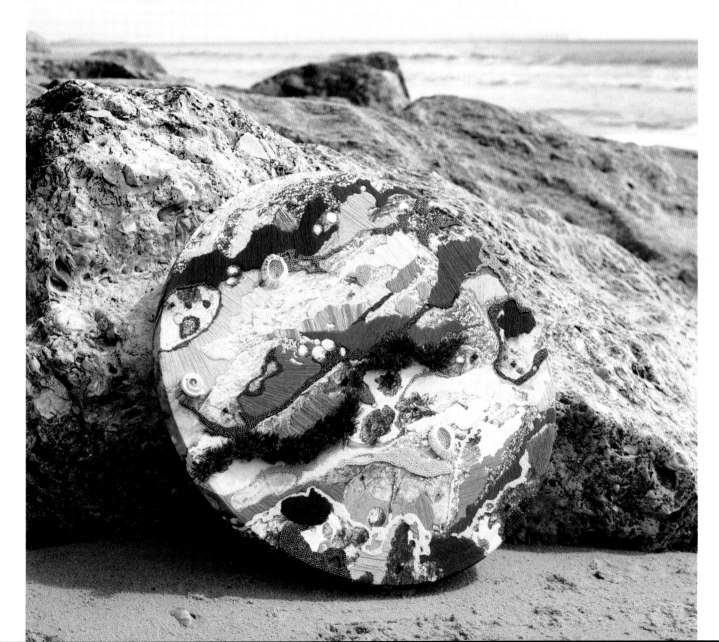

DEDICATION

For Evelyn.

ACKNOWLEDGEMENTS

Before anyone else, I'd like to thank my husband for saving my life,
long before embroidery did.
My mum, for supporting me throughout all the bad decisions and the
direction changes that got us to this point (not to mention flying halfway
across the world to help support us while I work).
And my kids who quite literally give me a reason to keep doing this.
I also want to take a moment to thank every single one of you that bought
this book, engaged with me on social media, attended workshops,
bought my work, featured me in magazines, or supported me in any way.
You make it possible for this to be my job, something I never could have
imagined at 14, begging for my creativity to be taken seriously. There will
never be adequate words to express my gratitude. Thank you.

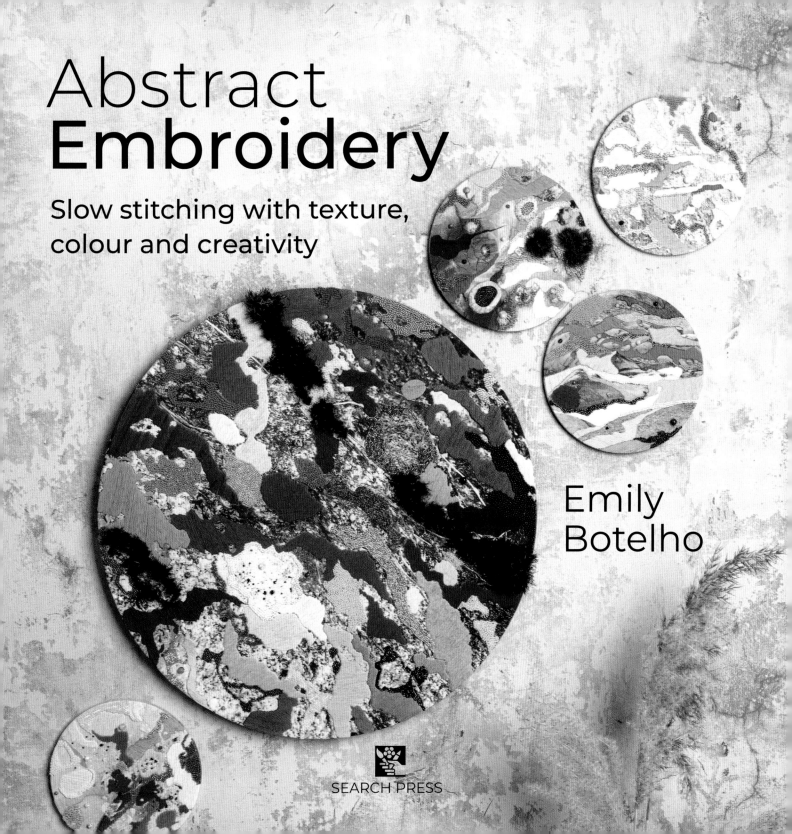

Abstract
Embroidery

Slow stitching with texture, colour and creativity

Emily
Botelho

SEARCH PRESS

Contents

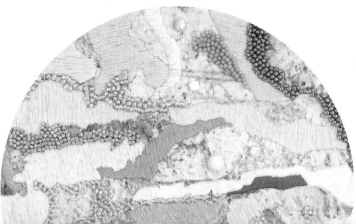

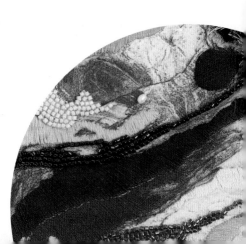

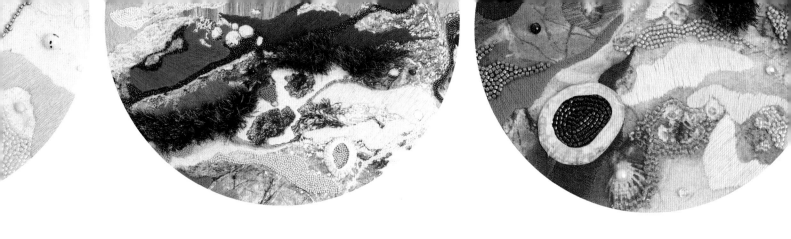

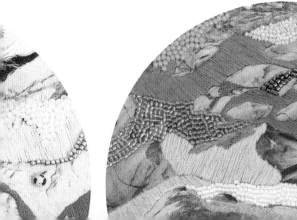
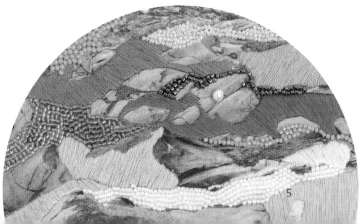
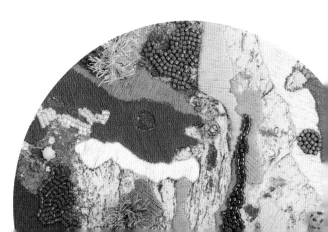

Introduction

I had never mastered the art of meditation, until I realized that's exactly what I was doing with a needle and thread: slow stitching. Embroidery, and everything that comes along with it, has quite literally saved my life. After a fairly severe period of depression in late 2017, I spent an extended time by the sea in North Wales to figure out who I was and who I wanted to be. I used a lot of this time experimenting with different art practices as my access to therapy was limited. During this time, stitching appeared as a somewhat meditative practice coming almost out of nowhere as a coping mechanism that helped me through a lot of mental health issues over a period of several months.

Fast forward six months and I was stitching full time, scheduling workshops around the world, and curating a beautiful online community of people who I was hopefully inspiring to look at the world around them in a totally new way.

With this book, I hope to give you an insight into my creative process, how to find your own inspirations, and a few tips and tricks to create your own abstract pieces.

I've been incredibly lucky to travel to some amazing places over the last few years that have very obviously influenced my work, but you don't need to go far to be inspired.

With that in mind, I focus on three distinct environments: coastal and seaside landscapes, alpine and mountain environments, and man-made and urban settings. Within these themes we'll look at where to find unique textures, colour palettes, and even things you can collect to use in your work. My hope is that you will experience these surroundings in a different and exciting way.

Since embroidery came out of the blue for me, and there's no nostalgic story of being taught by my grandmother or anything like that, I firmly believe that stitching is accessible for all skill levels, and although it is slow, you'll be surprised how quickly you notice improvement.

Try to remember that the nature of this style is that no one knows what it is supposed to look like apart from you. There are no patterns to follow or step-by-step guides. Only you decide when it's finished – which gives you the freedom to explore the textures that you're working with to create a piece unique to you.

Every single piece of work will be different, and that's the beauty of it!

SLOWLY, WITH NEEDLE AND THREAD,
I CAME TOGETHER ONE STITCH AT A TIME.

Tools and materials

One of the questions I get asked the most is how to source materials to work with. Wherever possible, I try to buy from local independent stores and small businesses.

Thread scissors

These are the most important tool I use. It's important to choose a pair that are comfortable in your hands, as you use them so much. I use small but sharp Victorinox scissors that have a very sharp point.

Fabric scissors

The number one rule for these is to only use them for fabric! That way they will last so much longer. Much like the thread scissors, comfort is key. My favourite is a pair of LDH scissors with silicone handles. I also use a pair of LDH Prism thread snips, for the areas of 3D texture that need a bit of extra strength.

Fabric

All of my pieces are created on cotton poplin that I have printed using the photographs of the textures I find. I use cotton poplin as it keeps good tension in the hoop, and also allows for precise detail when printed. I use machine embroidery thread, therefore my needles are quite thin. If you are using larger needles like traditional embroidery needles, you may want to experiment with different weights of fabric. I use a small family-run business in the UK to print my fabric, but there are many options online for custom fabric printing.

Thread

The majority of embroidery artists use typical embroidery floss for their work. However, I work exclusively with machine thread. Personally, I prefer working with more delicate materials and I find that the colours available vs the cost of materials is a much better balance. My personal favourites are Mettler, Gütermann and Madeira threads.

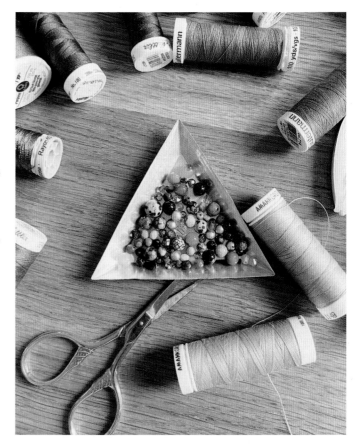

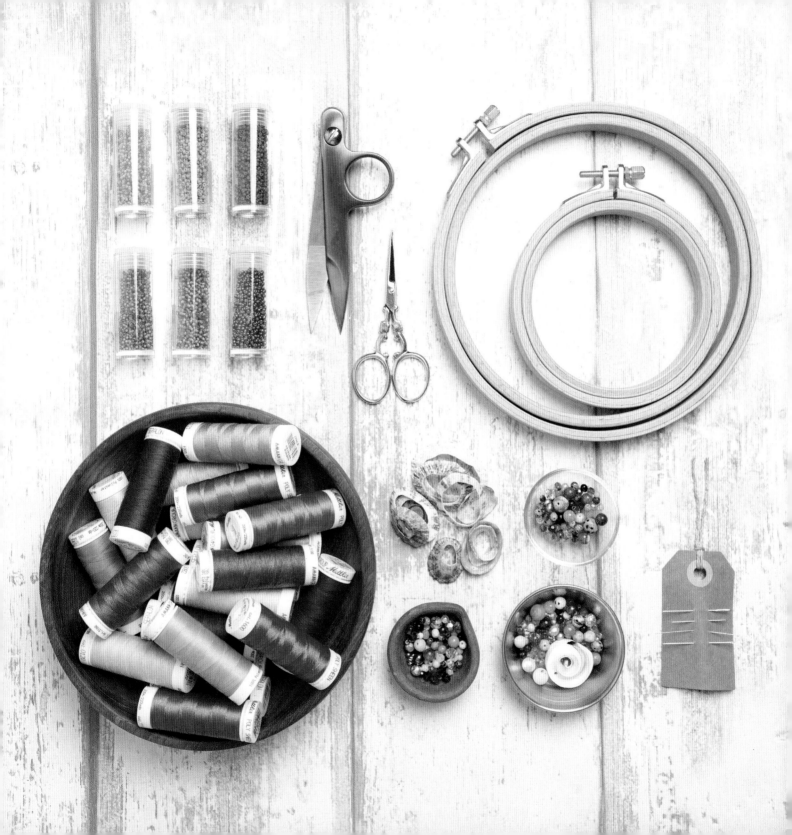

Hoops

As I tend to buy most of my supplies from small businesses wherever I find myself, I have used a variety of different brands of hoops over the years. However, I've found the best ones to use are Nurge embroidery hoops.

For larger pieces (above 20cm/8in in diameter) I would always recommend quilting hoops. The thicker band of the frames helps maintain good surface tension with larger pieces, and stops you having to pull the fabric tight as often.

Stands

There are a variety of embroidery stands available for different working styles, but I personally prefer to work with a floor stand when stitching larger pieces. It encourages me to sit with better posture for long stitching sessions (as I have a tendency to slouch on the sofa!).

Tapestry needles

To create the more 3D fuzzy textures with a modified version of Turkey stitch, I feed multiple strands of embroidery thread through a single needle, meaning I need to use needles with a much larger eye.

Tapestry needles work very well, just make sure the point is sharp enough to go through your chosen fabric as larger needles are often more blunt.

Thread needles

Frustratingly, my favourite needles to use happen to be mostly discontinued vintage ones I found in an antique store in the Swiss Alps, which makes sourcing new ones incredibly difficult! I have a stash that will last me a while, but the end is in sight! Once you find needles you love, I recommend stocking up.

Beading needles

The main thing to consider when choosing beading needles is that you select the correct size for the beads that you are using. Making sure the eye of the needle passes through the hole in the bead before you start stitching will save you a lot of frustration. I always recommend testing your needles on a small handful of beads to make sure it's the right fit.

From top to bottom: tapestry, thread and beading needles.

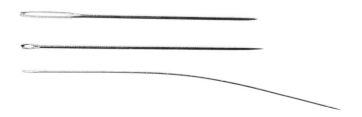

Beads

As I have been fortunate enough to travel quite a lot over the past few years, I've tried to buy beads in the places where I have found textures that inspire me. I work predominantly with brands like Miyuki and Toho for the smaller beadwork, but make a point of buying from small independent retailers wherever possible.

Larger beads

As with the smaller beads, I try to collect these wherever I go, including thrift stores, vintage sellers and antique markets.

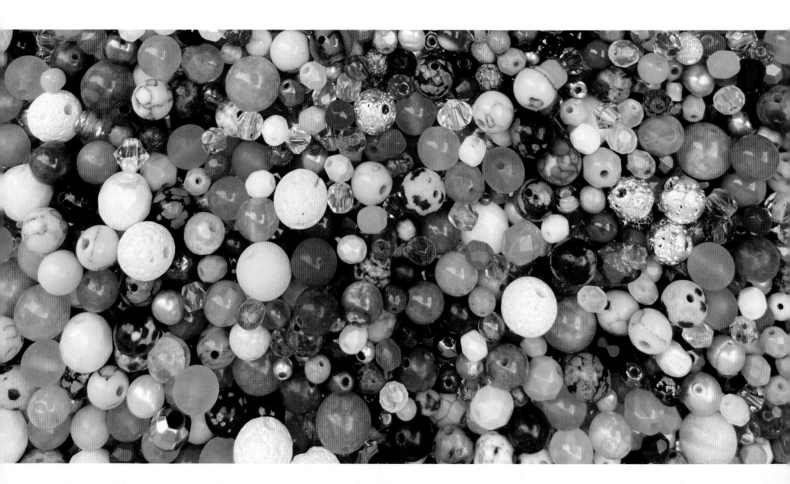

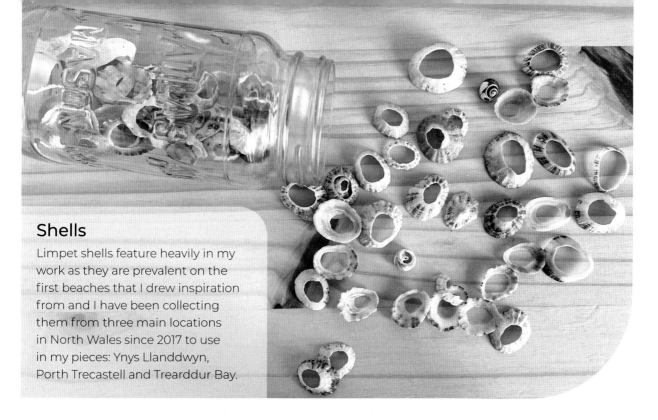

Shells

Limpet shells feature heavily in my work as they are prevalent on the first beaches that I drew inspiration from and I have been collecting them from three main locations in North Wales since 2017 to use in my pieces: Ynys Llanddwyn, Porth Trecastell and Trearddur Bay.

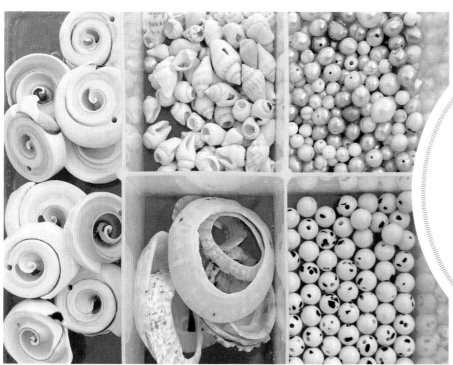

NOTE

It is important to note that all found materials that I have used in my embroideries have been collected mindfully in areas where scavenging for shells and so on is permitted. Always check your local area for any specific regulations, and to make sure you are not disturbing any ecosystems by removing shells or rocks.

How I work

Trying to pinpoint a formula for how I work is quite difficult, as the entire process is very intuitive for me. However, there are a few steps that are the same for each piece I create that you may find useful if you are exploring working in a similar way.

Every piece starts with a texture. How I first started looking for textures is largely a blur, but what has evolved over the past five years is a keen eye for detail, and purposefully seeking out areas that I think will translate well into an interesting finished piece.

When a texture catches my eye, I photograph it from a variety of different angles. I may play with the light and saturation of the images digitally to enhance some of the colours I can see but that my camera doesn't pick up.

Sometimes, a texture will stand out straight away and I can already envision the finished result. Other times, it's more of a 'trust the process' situation.

Once I have decided on a texture to explore, I have it printed onto cotton poplin and place it into a hoop to decide on the best composition. The size of hoop is determined by availability, mostly, but working on a larger scale is always my favourite so that I have space to thoroughly explore the detail within the piece. There is no formula to this, other than trusting your instinct of what works well in the space you have.

I then use the shapes and colour palette of the texture on the fabric to inform how I embroider. If the texture is interesting enough that I feel it can't be improved, for example a unique section of rock or a colour that I can't match with my threads, I leave it untouched.

I work into the individual sections with embroidery threads and beads, embellishing plainer sections, or sections that are crying out to have a 3D representation. Sometimes I know the exact beads I want to use to highlight a particular detail that I love such as the jet black sections of rock in Alpine 4 (page 90) where I used a Dalmatian jasper bead.

TIP
There are a range of textures available for you to download free from www.bookmarkedhub.com. Search for this book by title or ISBN: the files can be found under 'Book Extras'.

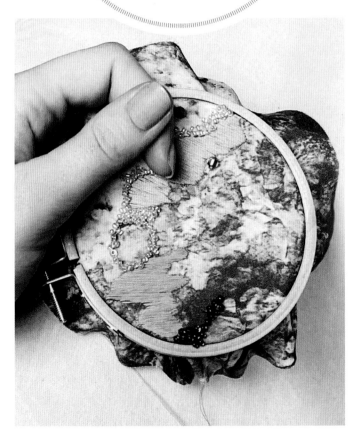

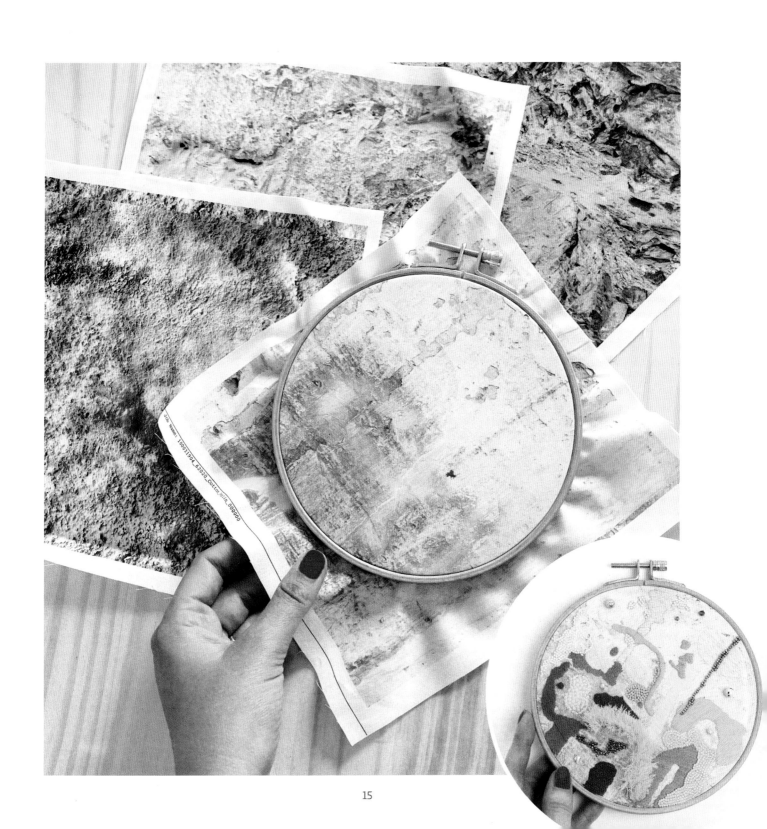

Photography:
hints and tips

I want to preface this section by saying you don't have to be the world's greatest photographer when looking for images to use in your embroideries. The camera on your phone, or an entry-level digital camera are good enough to start with.

There are a number of free editing apps that will help exaggerate the colours and detail in the photographs you take. Playing with the contrast, brightness, hues and saturation will bring different elements out of your images to highlight the details that you want to concentrate on.

As you can see, some examples are more extreme than others, but the key is to experiment until you can see the colours come through that you want to work with. With the image below, I increased the saturation to really make the pink and purple hues stand out.

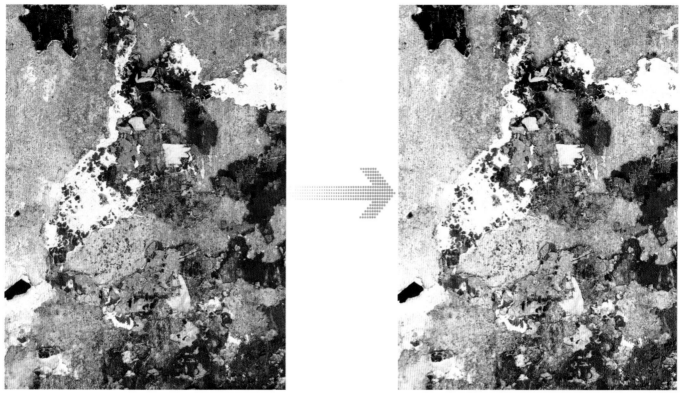

Original image.

Edited image.

With man-made textures, like this example of peeling paint from a wall in Porto, Portugal, I often photograph colours that you rarely see occur in nature. Because of this, I like to make sure that these form the basis of really vibrant pieces, often with neon thread and beads included.
I particularly liked the contrast between the flakes of paint and the background texture of the wall, so I increased the brightness so that you can see all of the details in the different textures.

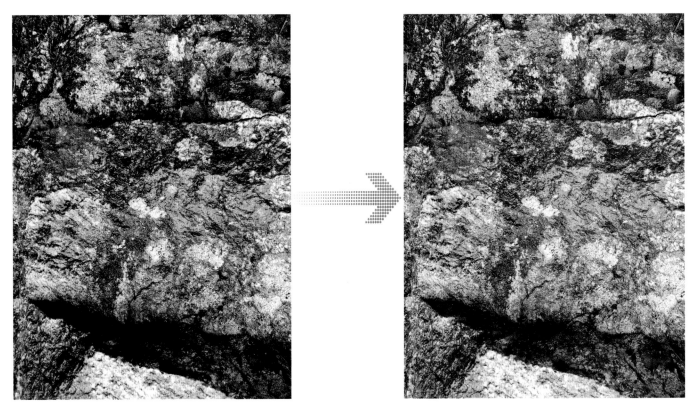

Original image.

Edited image.

Taking photographs of natural textures often means that you're not working in the best weather conditions. The photograph above of rocks in the Swiss Alps was taken on a rainy afternoon. In order to work with this texture, I had to lift the brightness to overcompensate for the cloudy skies and lack of natural light. I also lightened some of the shadowed areas to make sure no detail was lost. The camera on my phone doesn't quite pick out the colours I can see in front of me when there's low daylight, so I increased the saturation enough to emphasize the different colours in the rock face (but not enough to adjust the real-life look of the rocks).

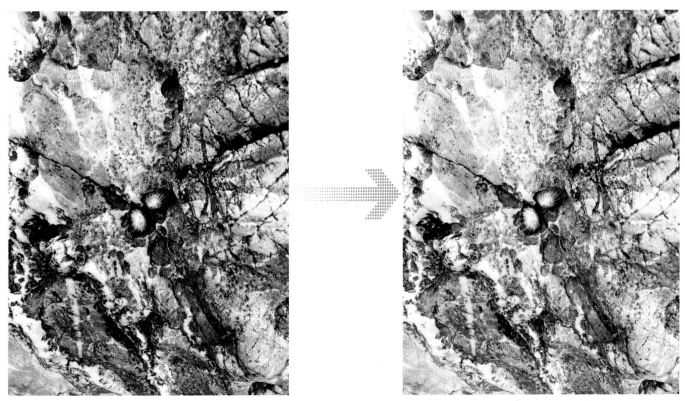

Original image.

Edited image.

Just as taking photographs in the mountains has its challenges, so does photographing texture in coastal areas. This image taken at Trearddur Bay in Anglesey, Wales required squeezing into rocky caves during low tide. It was quite sheltered from sunlight so I had to increase the brightness a little bit to mimic the light on the beach. I wanted to pull out some of the really interesting blue and purple hues in these types of rock so I also increased the saturation. With this particular image, I wanted the colours to be a little more surreal than normal to complement the taupe and beige colours in the limpet shells, so they are a little bit richer than they appeared in real life.

Composition and design

When considering the composition of a piece, I tend to stick to two main principles: colour and texture.

First, the colour palette of the texture often guides my decisions on how to balance the colour composition or simply how much of the background fabric to leave untouched. For example, if it is a particularly dark texture, I may purposefully select areas to include a lighter colour or highlight with lighter beads to ensure it doesn't seem too rich overall.

Second, I consider the specific textures I've captured within the image. Are there areas where I can improve on the colours that show through? Are there elements I wouldn't be able to replicate, for example marble colours on a rock face or swirls of green within areas of lichens and moss?

Outside of these formulae I often let the texture guide me on how to balance the composition.

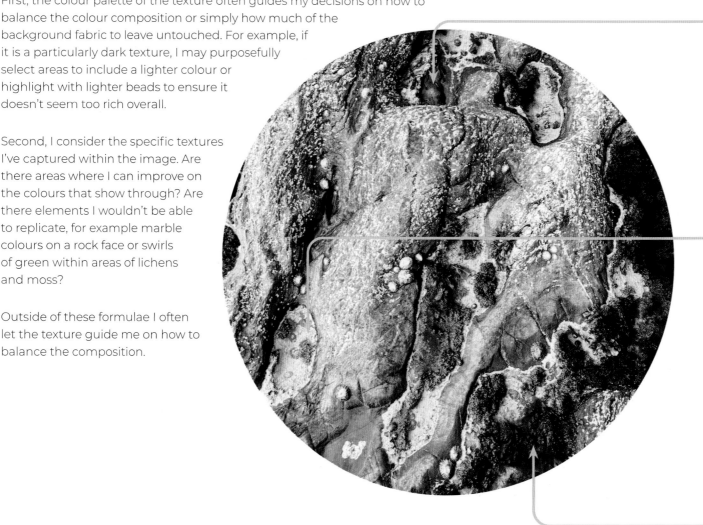

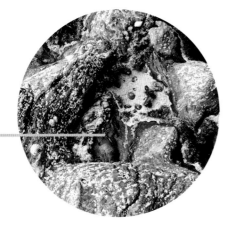

The key with your texture images is to look for interesting areas that you can expand on and draw attention to. I look for areas of brighter colour, different surface patterns or unique shapes.

Here you can see a nugget of brighter colour that caught my eye.

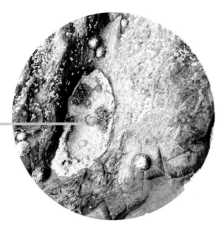

There are always areas that will be more interesting left without any embellishment – for example weird and wonderful textures that cant be replicated using threads or beads. The key is finding the right balance between what you embellish and what you leave.

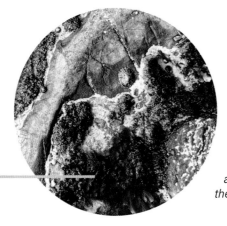

This section is a perfect example of where I'd consider adding a 3D texture. Although I can't always exactly replicate the textures I can see (for example the different types of seaweed and anemones found by the coast), adding areas of bead or 3D stitches allows me to introduce a new layer to balance the composition.

Techniques

Positioning your fabric in the hoop

1 Once you have chosen your fabric, unscrew the brass bracket at the top of the hoop.

2 It should be loose enough to pull the two rings apart.

3 Place the inside ring on a flat surface and position your fabric on top of the ring.

4 Place the outside ring on top.

5 Tighten the bracket and gently pull the edges of the fabric until your hoop sounds a bit like a drum.

Keeping good surface tension will help make your stitches neat and it will be easier for you too. Periodically throughout your stitching, just gently pull the fabric tight to make sure it keeps the tension while you're working.

It helps to trim the excess fabric around the edges so you don't tangle your threads when you work.

Once the fabric is in the hoop, I don't move it around. The composition is decided upon.

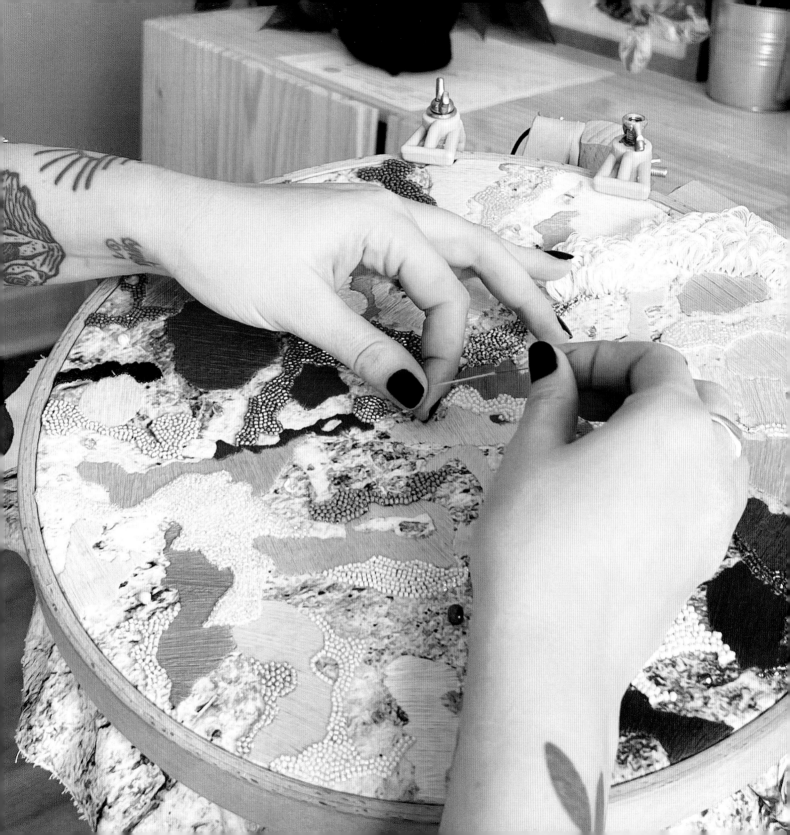

Satin stitch

Satin stitch makes up the majority of my work and is one of the easiest beginner stitches to master. It is used to fill in shapes with thread, and forms the basis of my overall technique.

Once you have decided on a colour thread, use the natural shapes in the fabric as your starting point.

TIP
You can use a fabric pen to help outline the shapes you want to fill in with stitches.

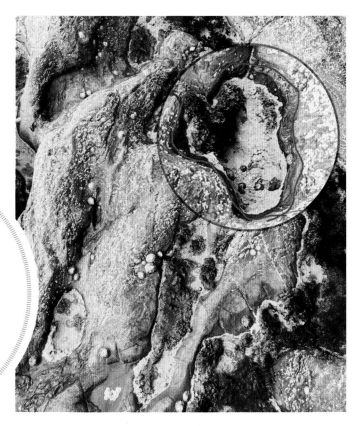

1 With your needle and thread, create one stitch that extends from one curved side to the other.

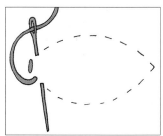

2 Bring the needle up again just next to the opposite side of the initial stitch.

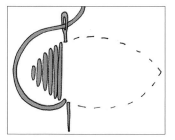

3 Keep the stitches close to one another, until you have filled in the shape you are working on.

3D textured stitches

To fill in mossy or grassy areas on my fabric, I use a variation of Turkey stitch to give a lovely, fluffy 3D texture. Similar to using satin stitch, I start by finding a section that I want to enhance with taller stitches, looking at the natural shapes in front of me. You can use a fabric marker to outline the area.

TIP
I use a thicker embroidery or tapestry needle for this stitch, as I often thread through multiple colours at the same time to add more depth to the final result.

1 I choose five or six different spools of thread, building up the colours I want to use, and thread all of the ends through the same needle to make a multi-strand thread.

2 Make one initial stitch. Bring your needle down quite close to the original stitch, and instead of pulling the thread tight leave a loop of thread.

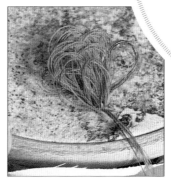

3 Make lots of loops of thread until you've filled in your desired section, making sure your last stitch comes through the front of the hoop.

4 You should now have an area full of 3D loops sticking out from the fabric, ready to cut.

5 Once you have trimmed the 3D areas you will have a fluffy, moss-like texture, perfect for representing grassy areas.

TIP
With traditional Turkey stitch, you can add an anchor stitch over the bottom where the two ends of thread meet the fabric to make it more secure. I prefer to add fabric glue/hot glue on the back of the hoop when I've finished the section.

25

Attaching shells

In order to attach shells to my hoops there needs to be a hole for the thread to go through. Not all shells work for this, but my favourite to use are limpet shells. I collect them from the beaches where I find the textures, which is a way for me to include something from the place that brought me the inspiration.

The best way I find to make holes in the limpet shells is with a small electric hand drill (mostly used in jewellery making). I prefer to drill a hole on either side of the shell to make sure it is well secured on the hoop.

1 Choose a needle that will easily fit through the holes in the shell.

2 Hold your shell in place on the fabric and prepare to stitch.

3 Stitch through the holes on either side of the shell to attach it securely to your piece.

Attaching beads

Attaching beads, whether they're small seed beads or larger embellishments, works the same as attaching shells.

First, make sure you choose a needle that fits through the hole in the bead, then choose your thread.

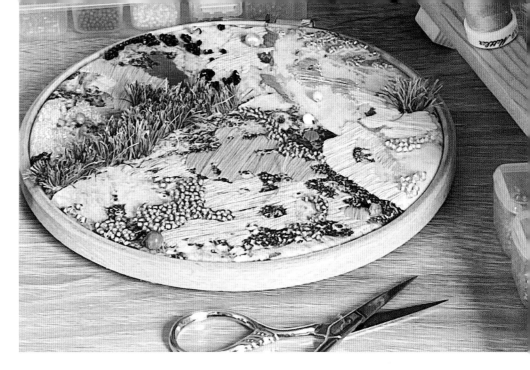

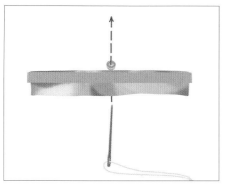

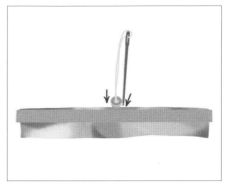

1 Insert the needle up through the back of the fabric and hold the bead with your index finger and thumb so that the hole is completely exposed. Insert the needle all the way through the hole in the bead. Slide the bead down the length of the thread until it is right up against the fabric.

2 Insert the needle back through the fabric on the other side of the bead. This will ensure that your stitch will span the length of the bead and the bead will lay flat against the fabric.

3 Pull the thread taut after you bring it through. Repeat this as many times as you want to fill in larger sections, or use individual beads to add smaller details to your hoop.

For larger beads like semi-precious stones, you can make another pass through the fabric and the bead to ensure that the bead will stay put. Bring the needle up through the same spot in the fabric as you did for the first stitch, insert the needle through the bead again, then bring the needle back down through the fabric again in the same location.

Finishing the back

There are many different ways to finish the back of an embroidery hoop, depending on how you want it to look.

 Personally, I like to be able to see the stitches that went in to creating each piece, so I simply trim the edges of the fabric and use a hot glue gun to secure the fabric edges to the inner ring of the embroidery hoop. This means the reverse of the embroidery is completely visible (although hidden when displayed in a frame or hanging on the wall).

 I've found that although it may not be the neatest option, it is the most secure way to ensure the finished hoop still keeps the same surface tension.

 Alternatively, you can cut a circle of felt and attach it over the back to hide the stitching if you prefer a cleaner finish.

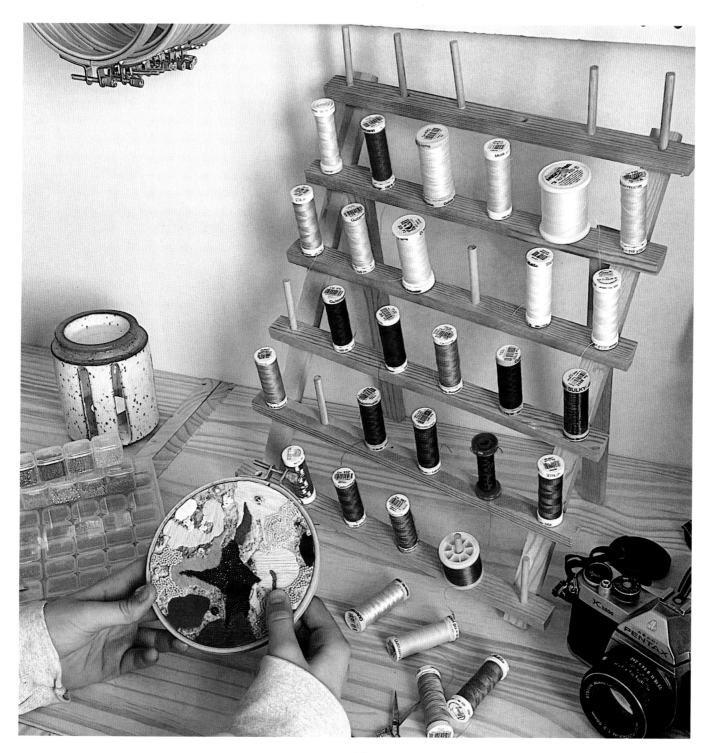

PROJECTS

Coastal and Seaside 32

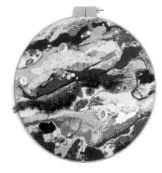

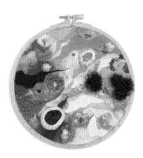

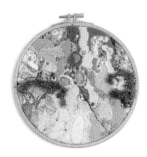

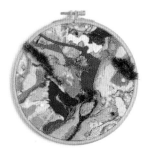

Project 1: 34 Project 2: 42 Project 3: 50 Project 4: 58

Alpine and Mountains 66

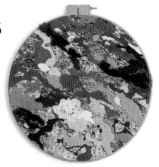

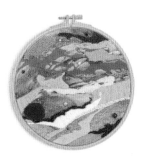

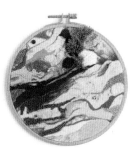

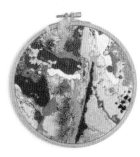

Project 1: 68 Project 2: 76 Project 3: 82 Project 4: 88

Urban and Man-made 94

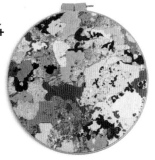

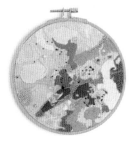

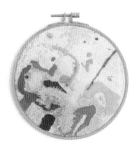

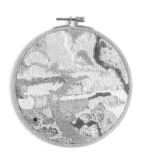

Project 1: 96 Project 2: 104 Project 3: 110 Project 4: 118

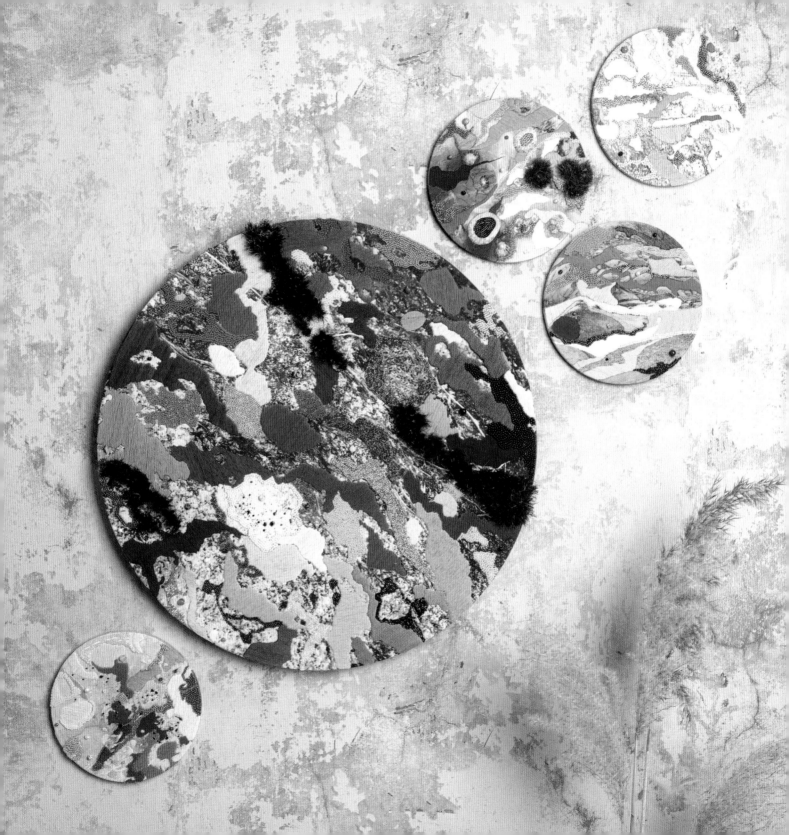

Coastal and Seaside

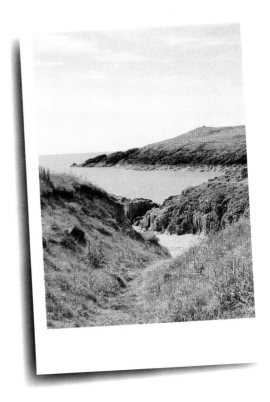

Coastal and seaside environments are arguably my favourite locations to find texture. The projects in this section were developed from textures found in and around the sea in North Wales. This is where my embroidery journey started, and the place I feel most inspired.

My coastal hoops are more 3D than the alpine or urban hoops, because they include found objects such as shells.

Blues and greens are my happy place...

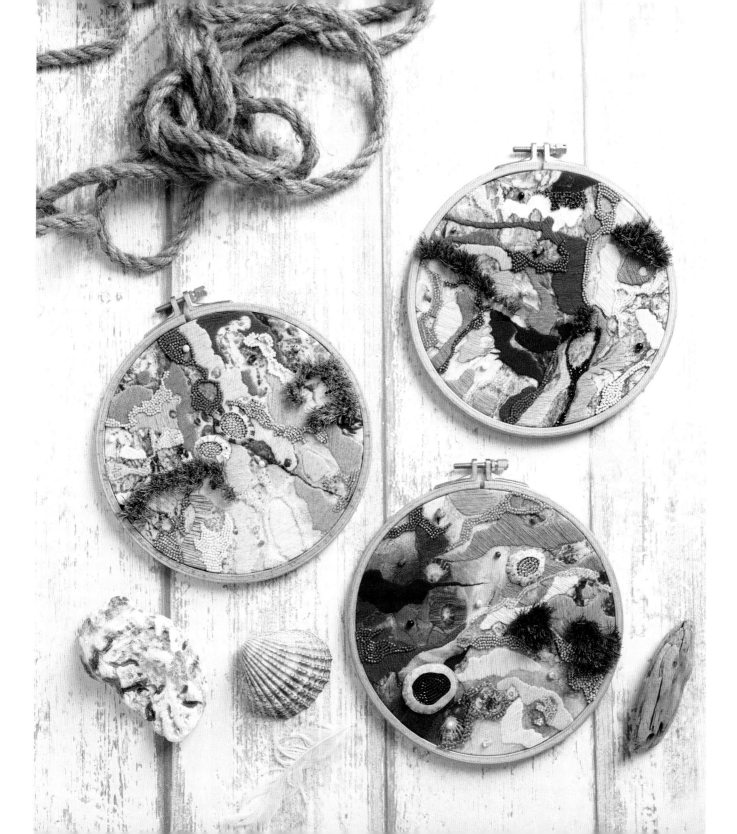

COASTAL 1

This is probably my favourite piece in the book. As I mentioned in the introduction at the beginning, embroidery came into my life when I was having an incredibly difficult time with my mental health. As a result, I spent a lot of time by the coast in Anglesey, North Wales, walking along beaches and exploring the shorelines. This section (and in particular this first project) is a love letter to Rhosneigr and everything it means to me.

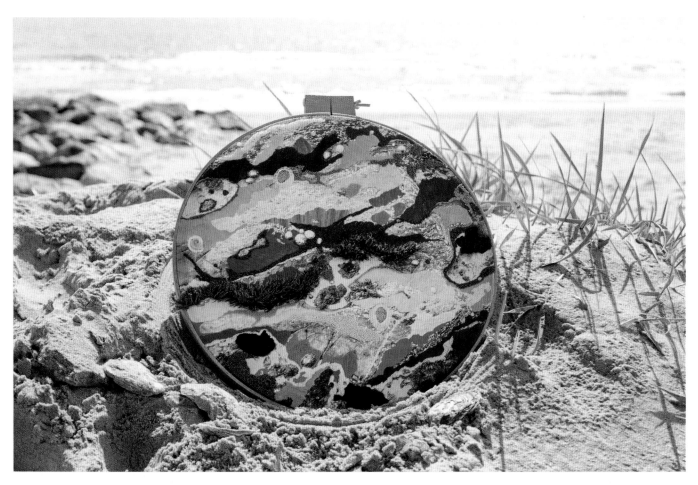

YOU WILL NEED

- 40–45cm (16–18in) embroidery or quilting frame
- Printed fabric of your choice
- A selection of embroidery threads, needles and scissors
- A mixture of small beads, as well as larger ones for adding details
- Limpet shells and small electric hand drill
- A lot of patience!

TIP

Quilting frames work better at keeping a good tension in the hoop at this size.

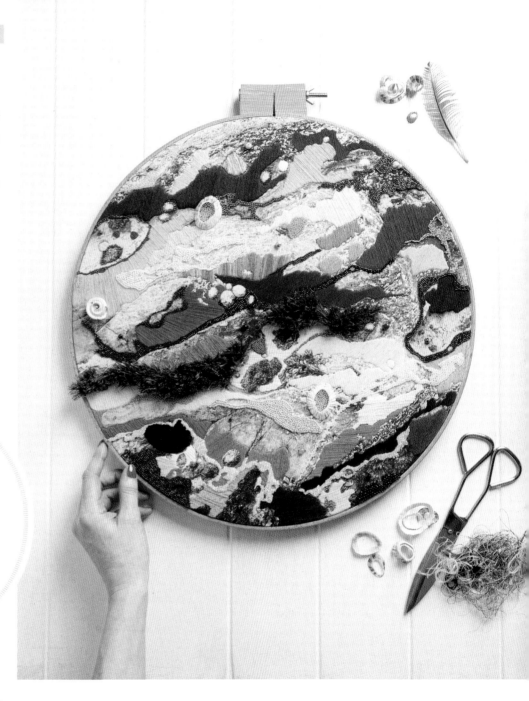

Inspiration

This piece was inspired by caves and rock pools at low tide. I fell completely in love with the textures that are found anywhere there is water and plant life.

The otherworldly colours that can be found in rock pools at low tide never disappoint, and have formed the basis of all four projects in this coastal section.

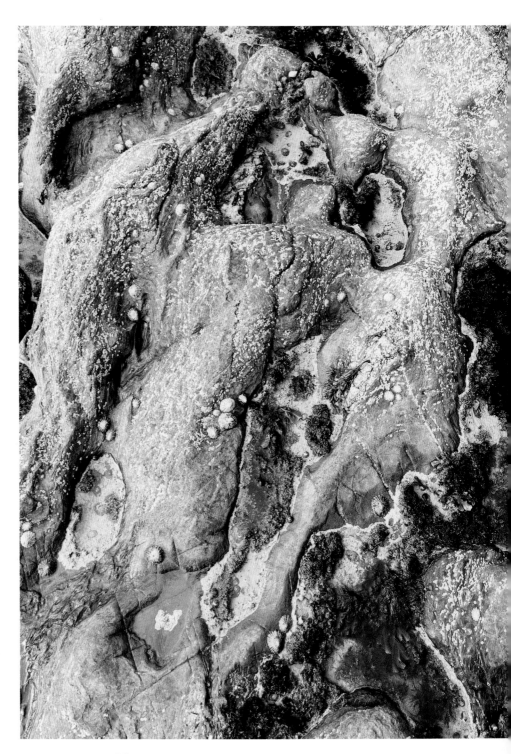

I spent two full days exploring the area at different times of day. I observed how the rocks changed colour with the light and how far the tide was in, mentally choosing colours of thread that I knew would work well with the collection of textures I was photographing.

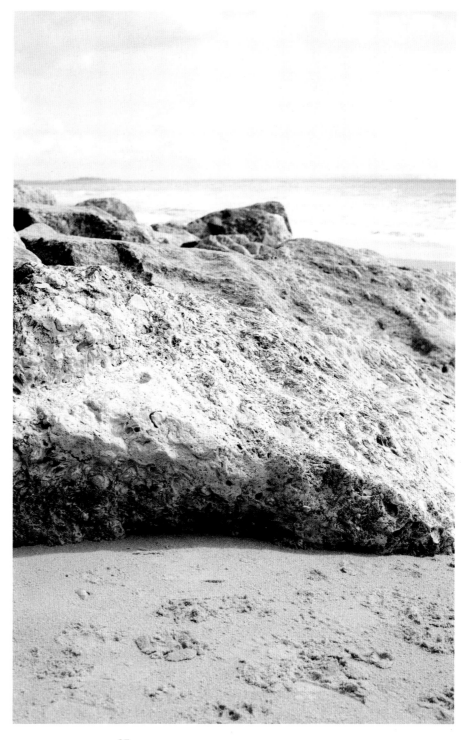

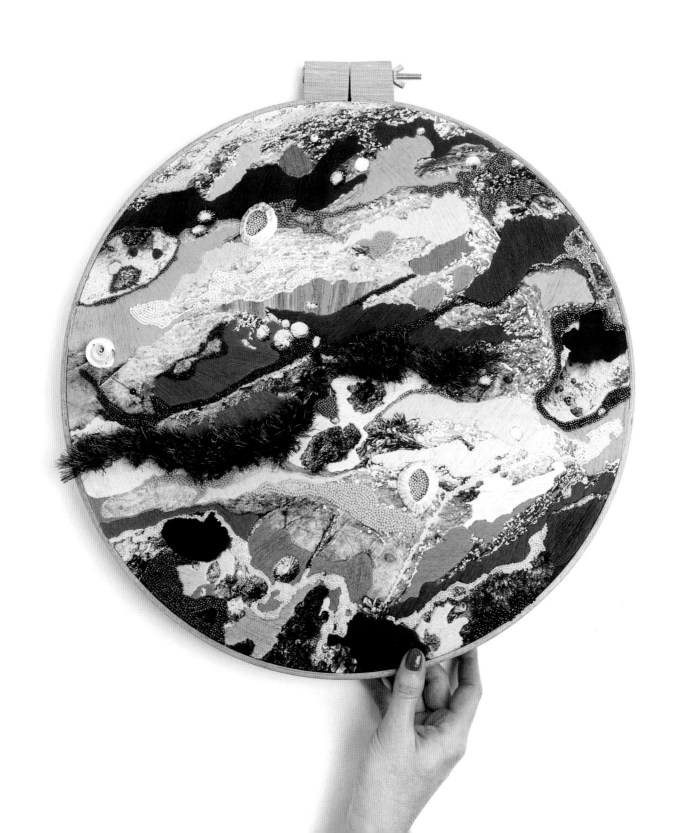

Details

Working on this scale allowed me to fully exploit the different details in the texture I chose, for example, exploring the fluffy 3D textures in the middle of the hoop.

The shells that feature on this work were all collected on the beaches that inspired it, which feels incredibly special to say.

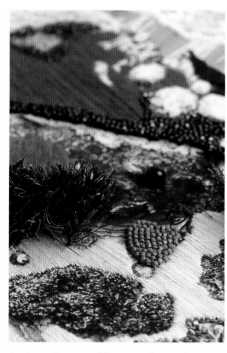

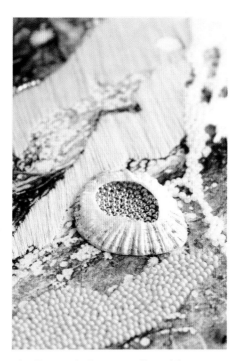

I selected seven different colours of green and brown thread in total to build up this section, which can appear to change colour as you look at it from different angles – much like when you see seaweed in the rock pools with the moving tide.

The limpet shells were collected from a beach called Trearddur Bay, which has by far the most interesting landscapes I've found on the coast. I included beads inside the shell to try and mimic the life inside these pools.

The vibrant colours in front of me allowed me to experiment with the variation of colours in the beads I chose for this piece. I currently have a collection of around 75 different green beads, and I used a fair amount of them in this piece alone to try and do justice to the amount of colours you can find in these textures in the wild.

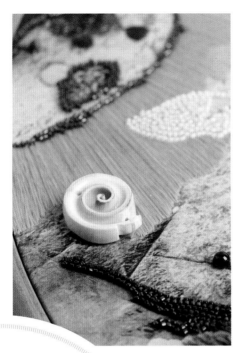

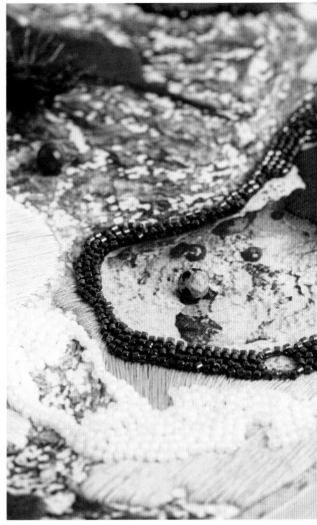

TIP

Although this piece was inspired by the coast (specifically in North Wales), you can find life anywhere you can find naturally occurring water. Whether that's exploring your local lake shore and the rock formations on the beaches, or the algae and reeds that grow near the pond in your local park, or searching for large puddles after the rain, you will be amazed at the textures you can find in nearby water sources.

Here you can see a section of the fabric I intentionally left free from stitches. To me, this section was far more interesting than I could have recreated with thread so I chose to highlight the area with delicate beads to allow the texture to stand out.

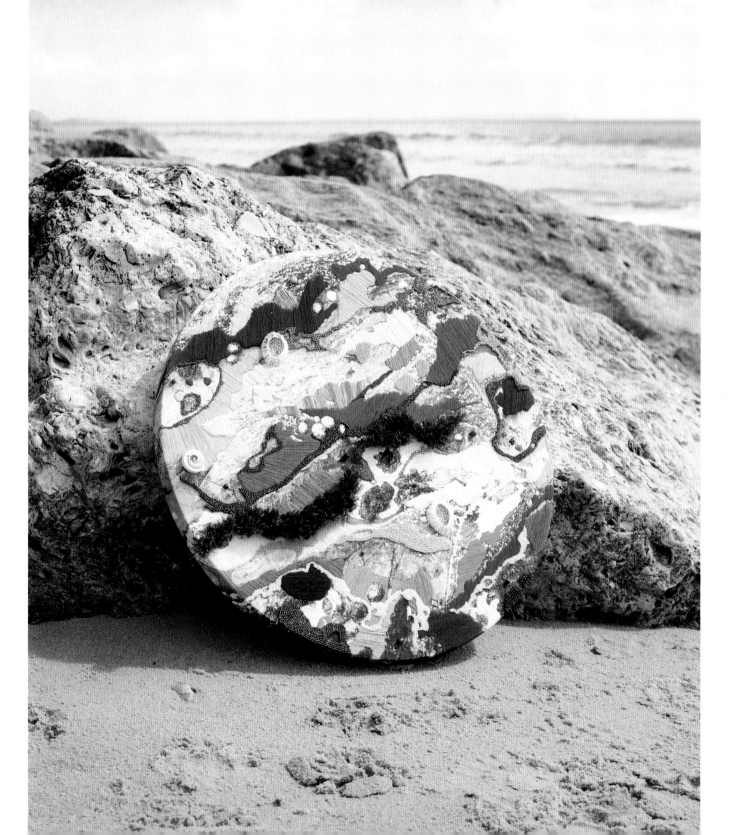

COASTAL 2

This piece is heavily inspired by the colours found in the pillow rock lava formations on Llanddwyn Island in North Wales.

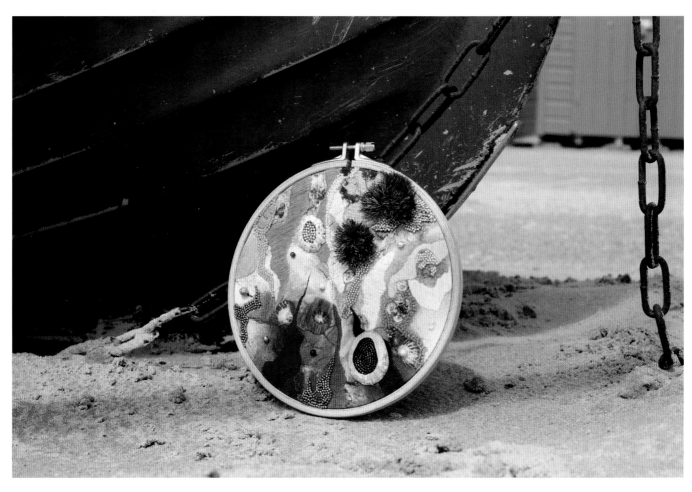

YOU WILL NEED

- 15.25cm (6in) embroidery hoop
- Printed fabric of your choice
- A selection of embroidery threads, needles and scissors
- A mixture of small beads, as well as larger ones for adding details
- Optional shells or other found objects and small electric hand drill

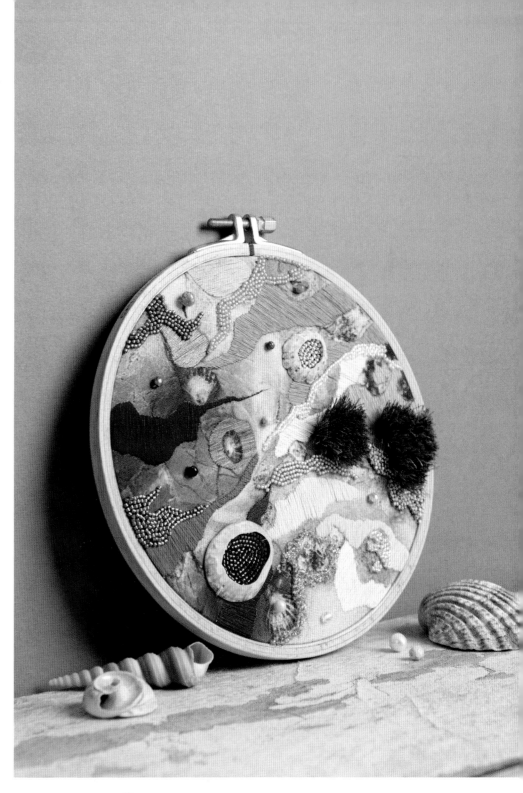

Inspiration

This texture is especially significant for me as it is somewhat of a hidden gem, in the sense that you can only really see it when the tide is low enough and you happen to know where to look.

The pinks and purples that you can see in this photograph are actually that bright in real life, and absolutely spectacular. I love how there is a real gradient between the rich deep pinks and almost golden sections of the rock.

Similar to Coastal 1, I spent about two days taking photographs at various times of day to try and capture the different colours in the rock and how they alter with the changing levels of water. I then settled on this final texture.

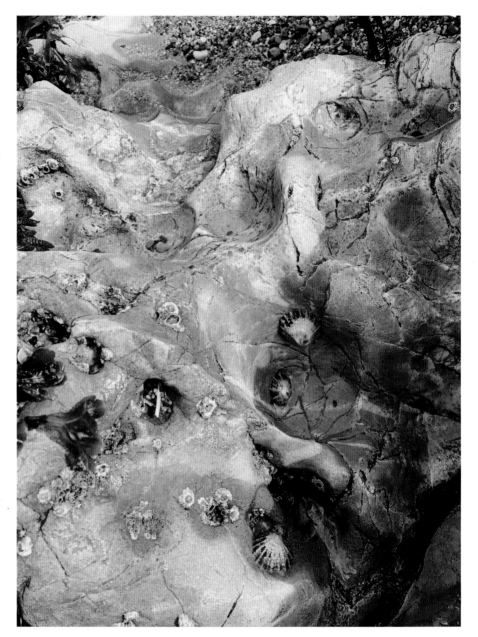

Details

The limpet shells add an interesting burst of detail to this piece and I have included shells that I found on a nearby beach.

As a side note, I never remove limpet shells from rocks, I only take what has already been discarded by the sea!

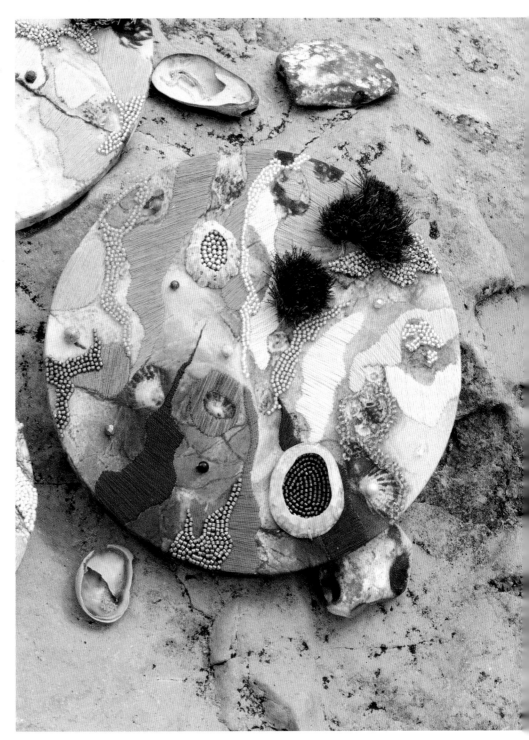

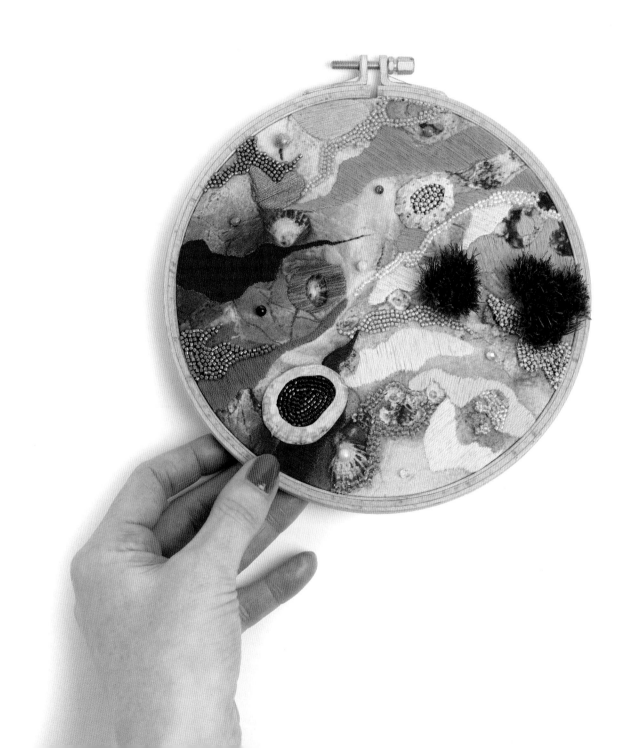

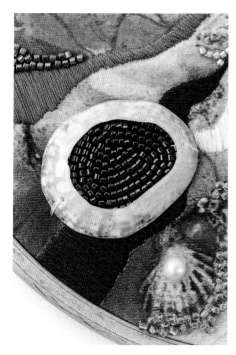

I spent a lot of time comparing the colours in the rocks to the selection of beads I have in my collection. I tried to highlight as many different shades as I could, including beads that have an almost splattered effect to attempt to mimic some of the textures I could see.

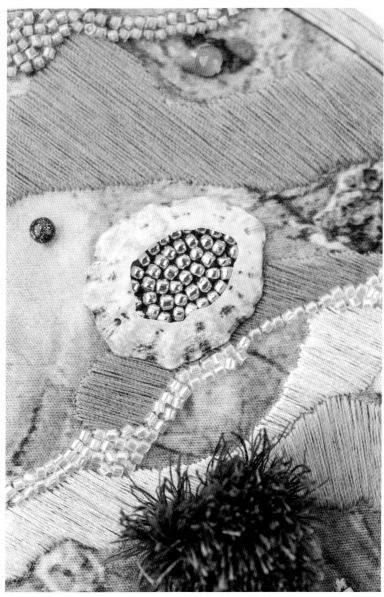

For the shell pictured here, I wanted to highlight how the sun hits the water when these rocks are still wet at low tide. I chose to use a metallic gold seed bead to mimic the sun as much as possible, but also to balance the choices of colours throughout the rest of the composition.

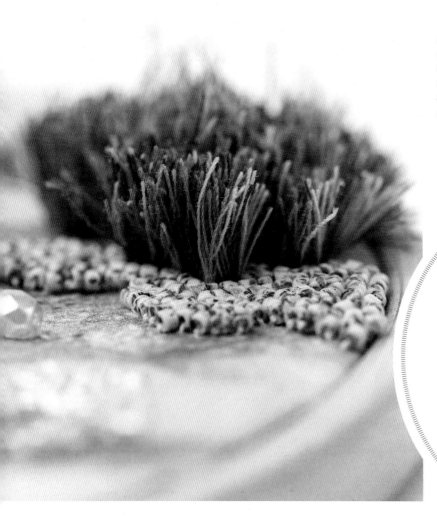

I used five different colours of green and brown thread to create areas of 3D texture that act as a nod to the anemones that grow in the tiny pools formed on the surfaces of these rocks when the tide is fully out. I also cut these threads slightly longer than I would normally, to add some extra movement into the piece.

TIP

While this piece is based on a very specific rock formation, and pillow lava doesn't occur everywhere, you can find interesting rocky areas in almost every environment. When I discover somewhere new to explore for textures, I research the geology of that place for extra information. You'll be surprised how many different textures of rocks there are in urban settings, including stone buildings, flooring in old buildings, and rocks used in local parks.

As this project utilizes a lot of different pink tones, I lined up as many pink threads as possible and held them repeatedly against the fabric and against the threads I'd already used in the piece. I wanted to make sure I was selecting the right pinks and adding as much depth as I could see in the original texture.

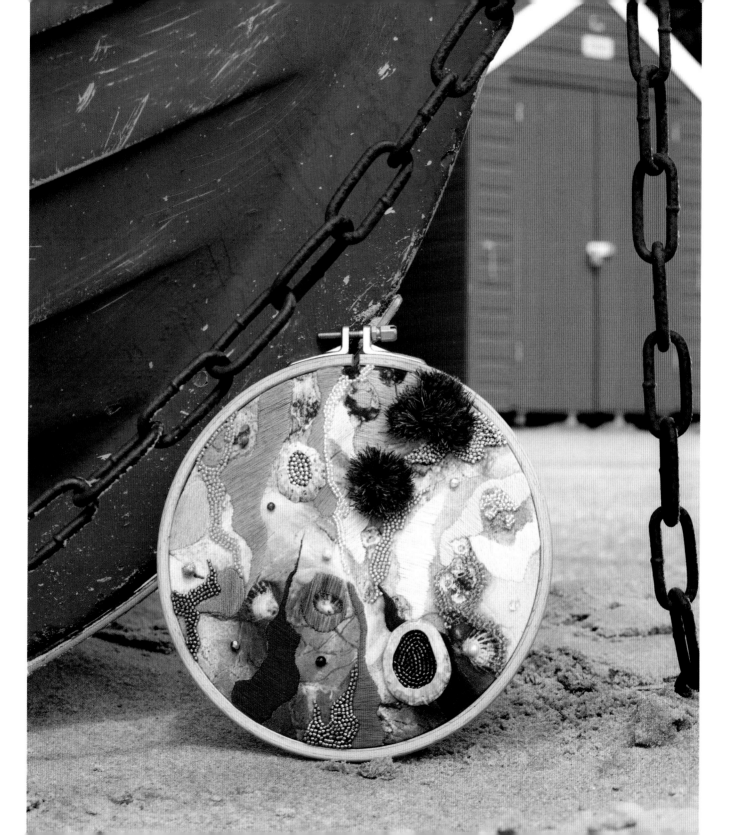

COASTAL 3

My third piece in this coastal theme was inspired by another set of rock pools found at low tide in North Wales. This time, I focused largely on the variety of specific textures you come across when the tide is completely out.

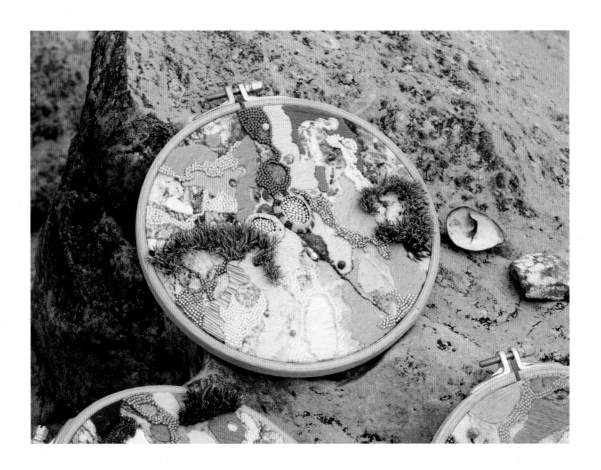

YOU WILL NEED

· 15.25cm (6in) embroidery hoop
· Printed fabric of your choice
· A selection of embroidery threads, needles and scissors
· A mixture of small beads, as well as larger ones for adding details
· Optional shells or other found objects and small electric hand drill

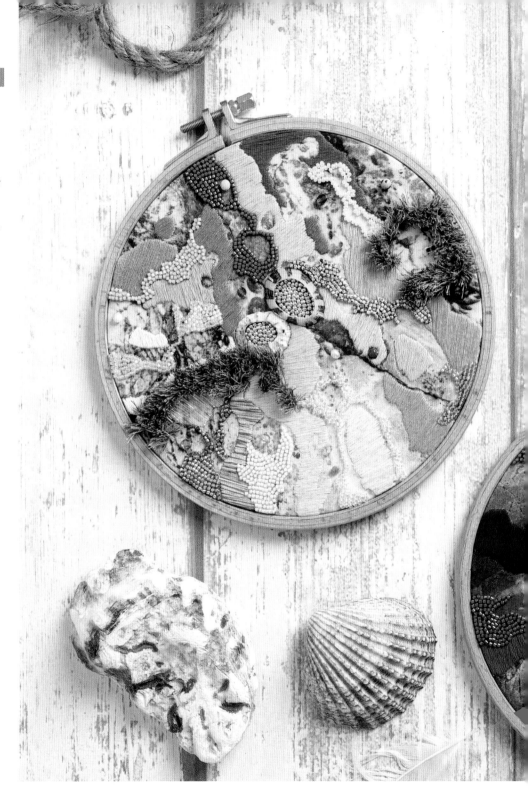

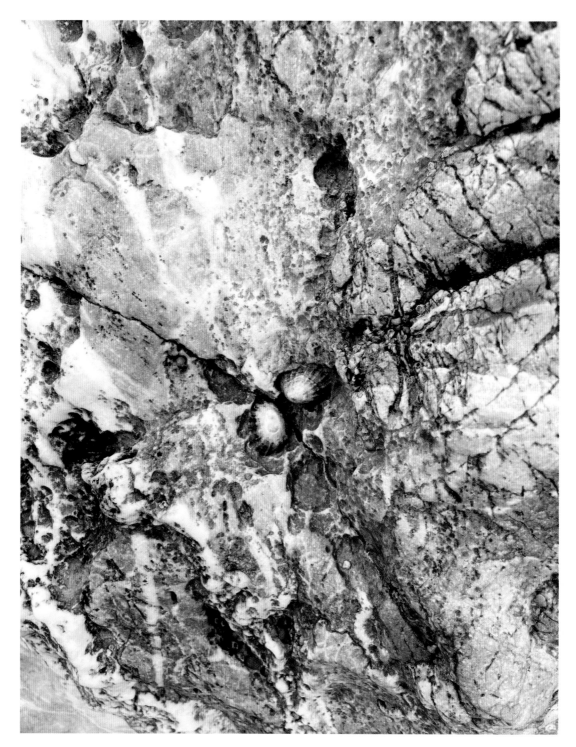

Inspiration

The rock pools contain all manner of different shapes and colours – mostly from a mixture of seaweeds and anemones – that can change from week to week or even from day to day. I also focused a lot on the rust deposits that are left by old boat chains that have been left to degrade in the water. 'One man's trash is another man's treasure', as they say!

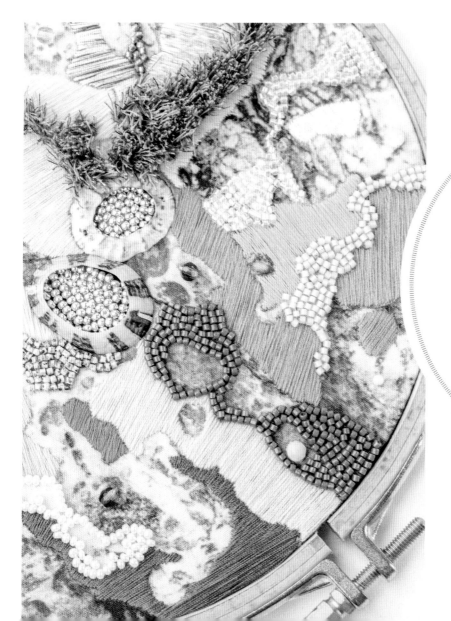

TIP

Although this particular texture was found on a beach at low tide, you can find very similar deposits of rust and oil in most cities. If you head to water, try and find man-made structures nearby such as bridges or docks. Anywhere where metal meets a water source you are likely to find a combination of natural textures alongside a wild spectrum of man-made colours.

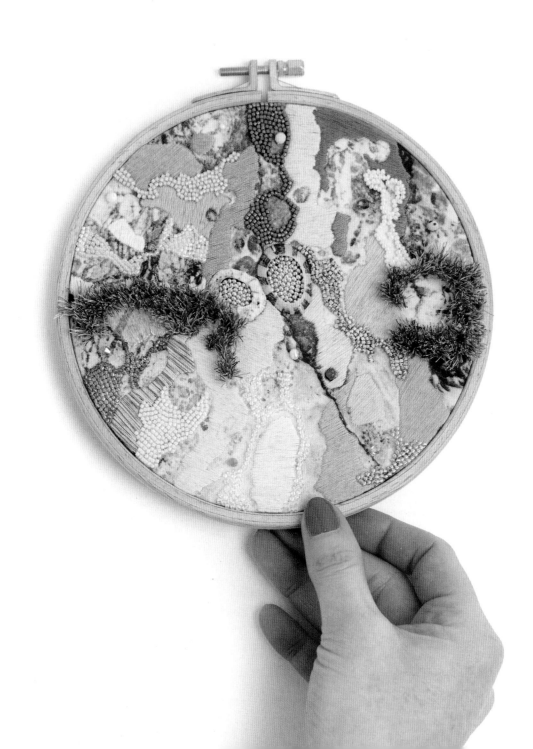

Details

With this texture, there is a great mix of what I would call 'naturally occurring' colours such as the greens and browns I've used to represent the different seaweeds and grasses growing in the pools, but also flashes of bright pinks, yellows and purples that seem somewhat out of place for the environment. A lot of these colours are formed by oil and diesel that have made their way into the pools from boats.

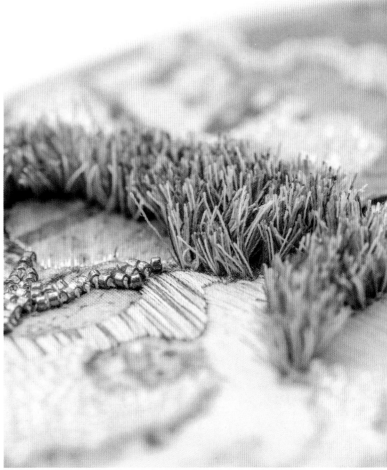

One of the benefits of having such a large collection of beads to work with is that, when I'm faced with a specific shade like the purple represented in this tidal pool, I can match it as closely as possible to what I see in front of me.

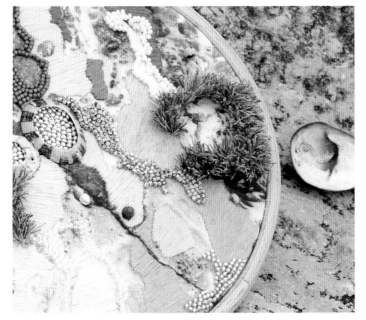

As with all the pieces in the coastal theme, I wanted to try and add as much depth as possible to the areas of 3D texture (in this case the seaweed found in the area). I therefore selected a mix of olive and moss green threads, with one or two strands of different shades of brown.

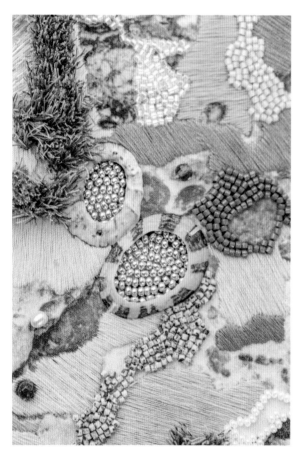

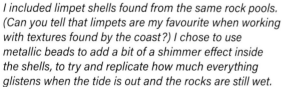

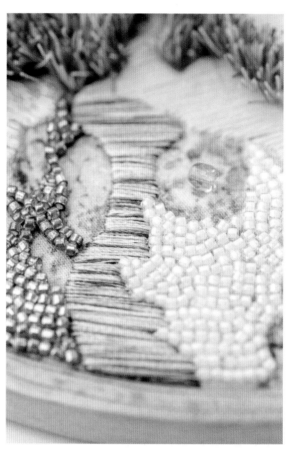

I included limpet shells found from the same rock pools. (Can you tell that limpets are my favourite when working with textures found by the coast?) I chose to use metallic beads to add a bit of a shimmer effect inside the shells, to try and replicate how much everything glistens when the tide is out and the rocks are still wet.

When it comes to the direction of satin stitching, I often try to change the direction of the stitches in relation to the 'right side up' of the hoop. I do this to make sure that the stitches don't accidentally end up too uniform as I think the changes in direction complement the abstract nature of the pieces.

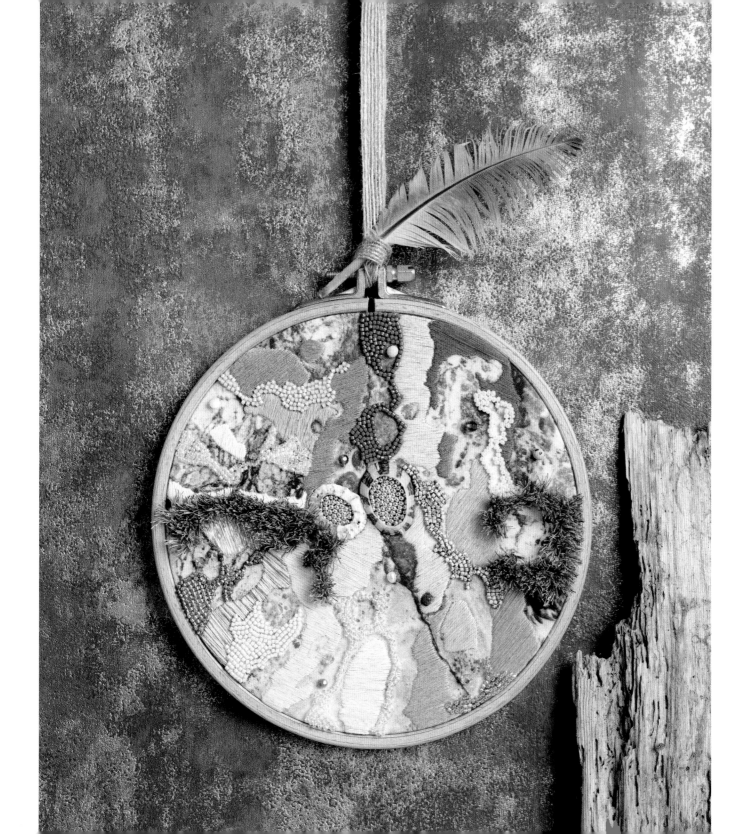

COASTAL 4

For the fourth project in this section, I explored the different types of rocks I could find at the beach, and I settled on an example of quartz deposits at Cable Bay in North Wales.
I wanted this piece to feel as otherworldly as it looked in real life, and I was keen to ensure all of the colours I could see were represented in some way.

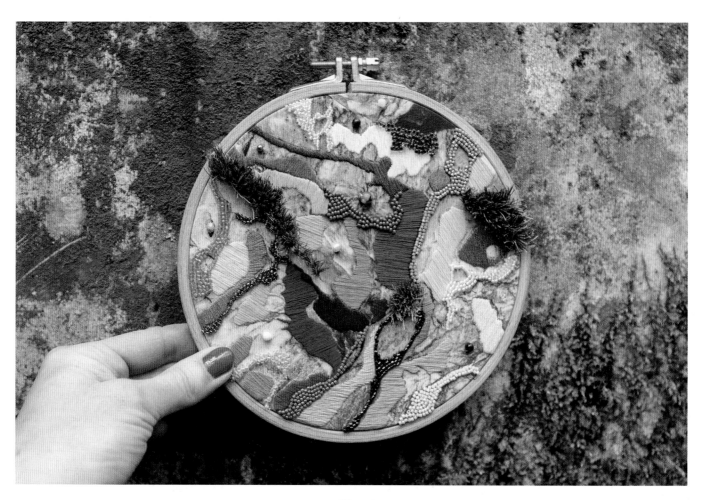

YOU WILL NEED

- 15.25cm (6in) embroidery hoop
- Printed fabric of your choice
- A selection of embroidery threads, needles and scissors
- A mixture of small beads, as well as larger ones for adding details
- Optional shells or other found objects and small electric hand drill

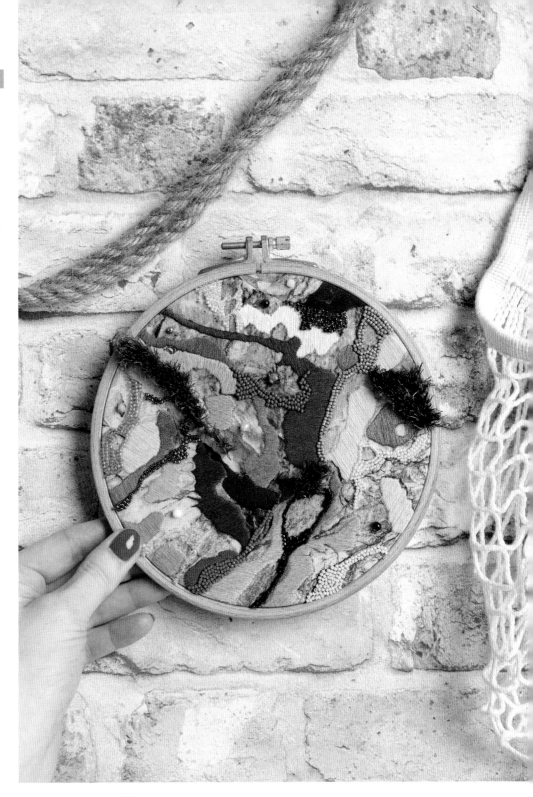

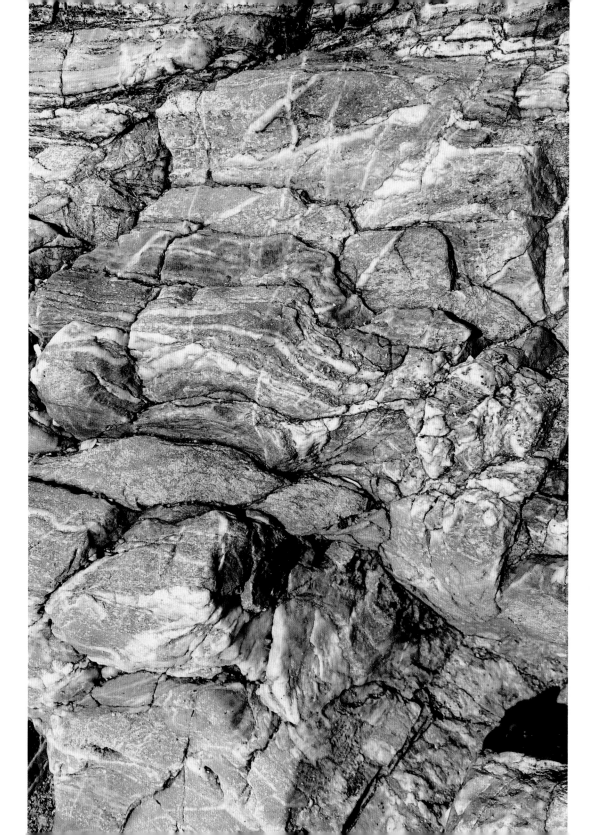

Inspiration

I was absolutely fascinated by the strata that seem to have formed, looking almost like veins running through the different purples, pinks and blues.

I spent a full day taking photographs from different angles and at various times of the day as the shadows changed the intensity of the colours. I settled on the photograph opposite to turn into an embroidery piece.

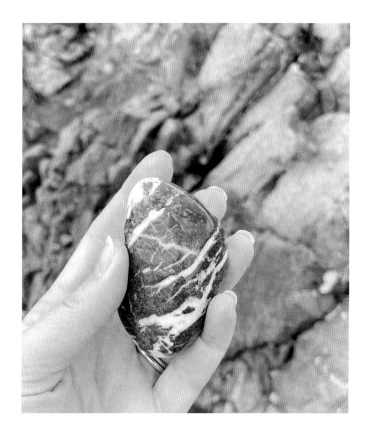

Even though I was focusing on the colours of the rock, where there is water there is life, and you can still see areas of lichen and moss trying to grow in the crevices.

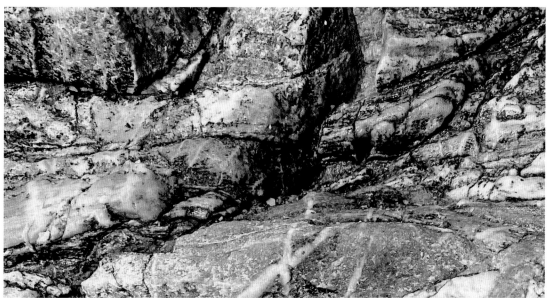

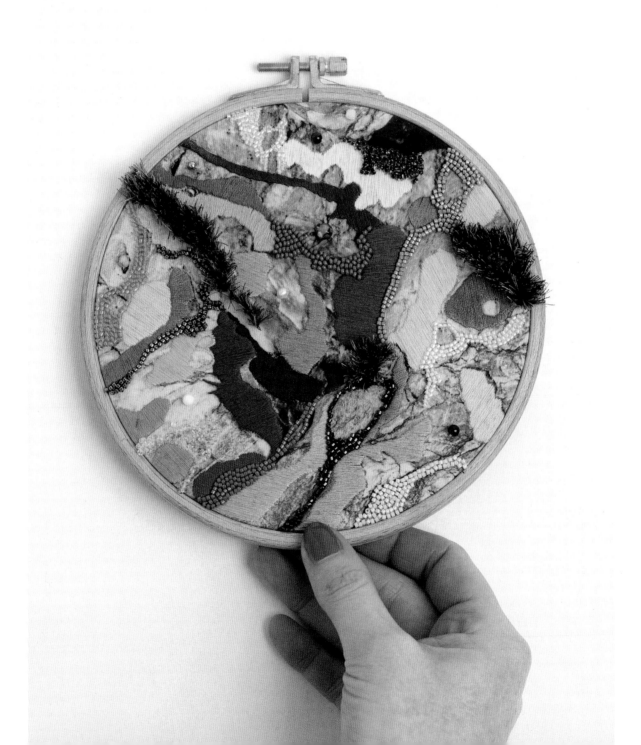

Details

Even though the texture for this piece is focused around the strata in the rock, I wanted to retain details of the overall environment as a nod to the inspiration behind all of my coastal-inspired pieces. I chose to leave areas of negative space within the sections of green metallic and olive green Miyuki beads to mimic the eddies and whirl patterns that you see on the surface of the water when it flows into tide pools and around the rocks at the shore. This creates a tangible sense of movement in the piece.

Negative space can also be used to highlight areas of the texture that are particularly interesting, that you don't think you could improve on by adding thread or beads, such as the green and pink melange inside the dark green metallic beads.

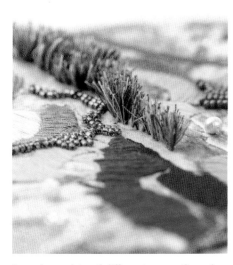

I used a variety of different green threads with a few flashes of yellow to create the 3D texture for the mossy areas. I also used some very iridescent green beads to highlight thinner areas where moss was trying to grow in the cracks.

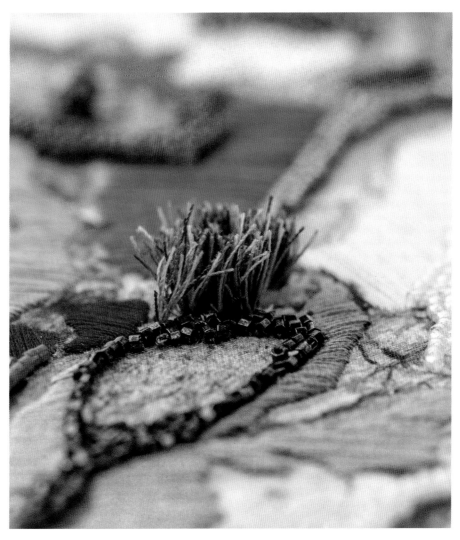

Colour

There are no shells on this piece, as the rock was higher than the water line so limpets and mussels aren't found. I decided instead to focus on the range of colours as details in the hoop.

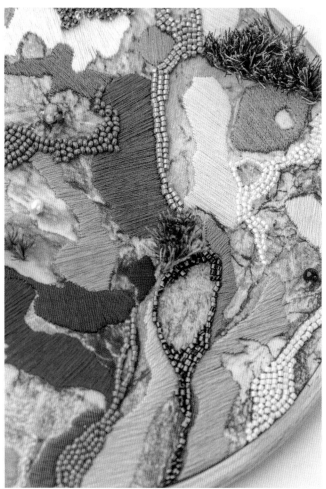

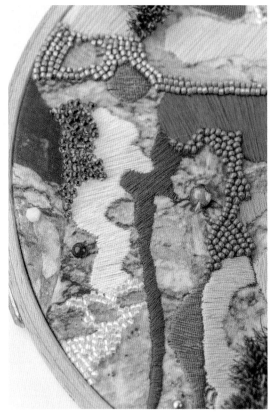

The golden and caramel sections of this hoop are my favourite because they offer such a stark contrast to the main colour palette in the rocks. I chose to focus on these sections with this piece to show off just how many colours you can find once you start looking.

Similar to Coastal 2, I spent a lot of time holding up many different colours of thread to the fabric to make sure I was selecting the right ones and doing justice to the original texture.

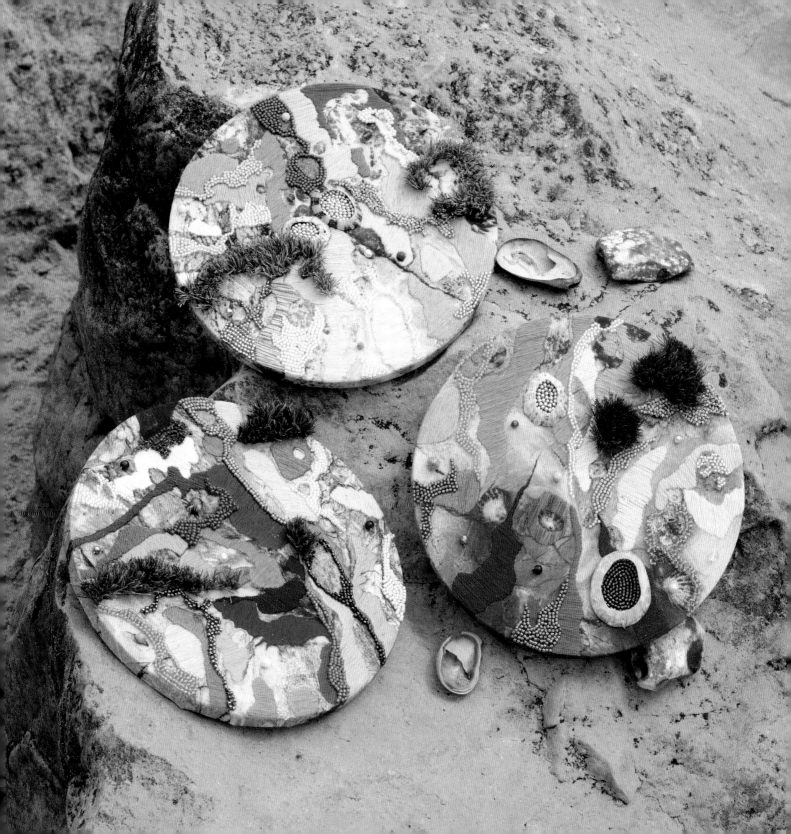

Alpine and Mountains

The textures used for these pieces were found during two summers when I travelled around Switzerland in 2018 and 2019. These are extremely special places for me, and were transformative in how I looked at textures going forward. For me, the beauty of these landscapes is how quickly the colours can change from one area to the next. I hope you enjoy them as much as I do.

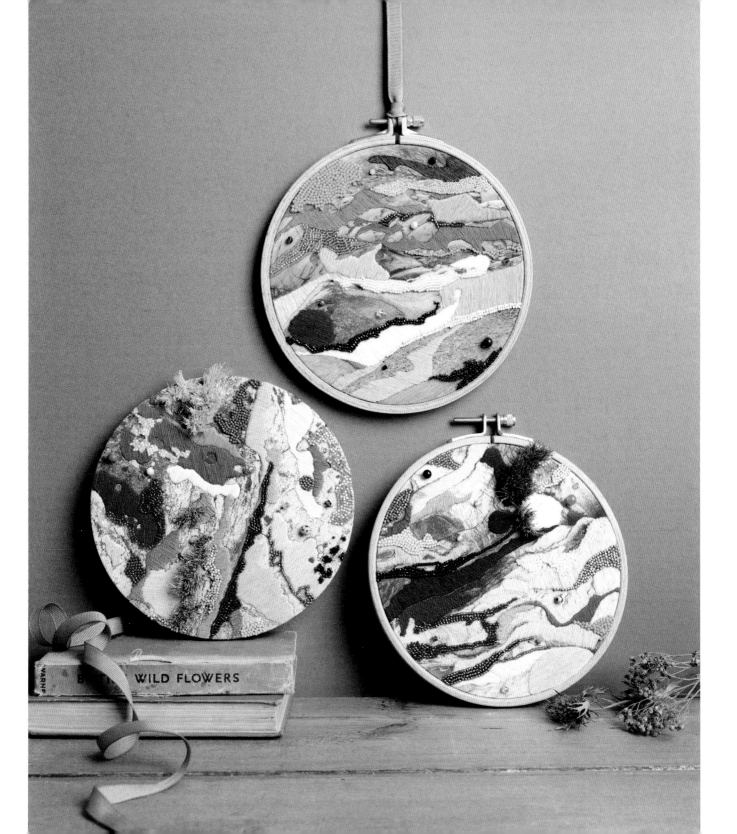

ALPINE 1

Although my pieces are based on specific textures that I choose for each one, the inspiration for this hoop comes from the whole region of the Swiss Alps.

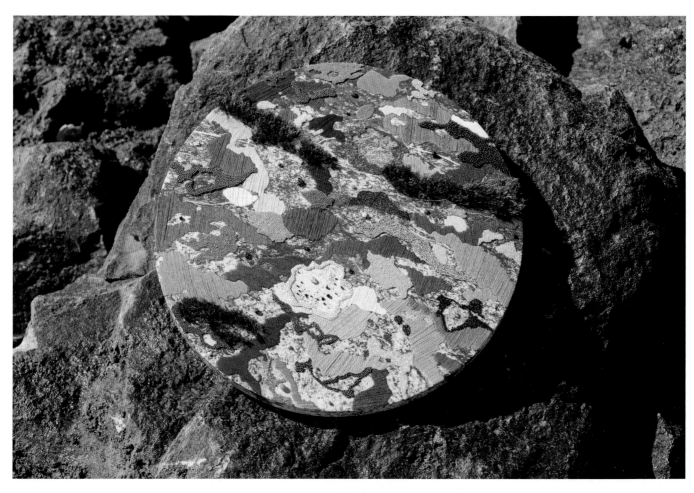

YOU WILL NEED

· 40–45cm (16–18in)
embroidery or quilting frame
· Printed fabric of your choice
· A selection of embroidery
threads, needles and scissors
· Embroidery needles to
hold thicker thread for the
3D sections
· A mixture of small beads,
as well as larger ones for
adding details

TIPS

Quilting frames work better at
keeping a good tension in the
hoop at this size.
I also find it helpful to use a good
floor stand so that you have both
hands free for the larger sections
of thread – your arms can get quite
tired when you are filling in areas
close to the middle of the hoop.

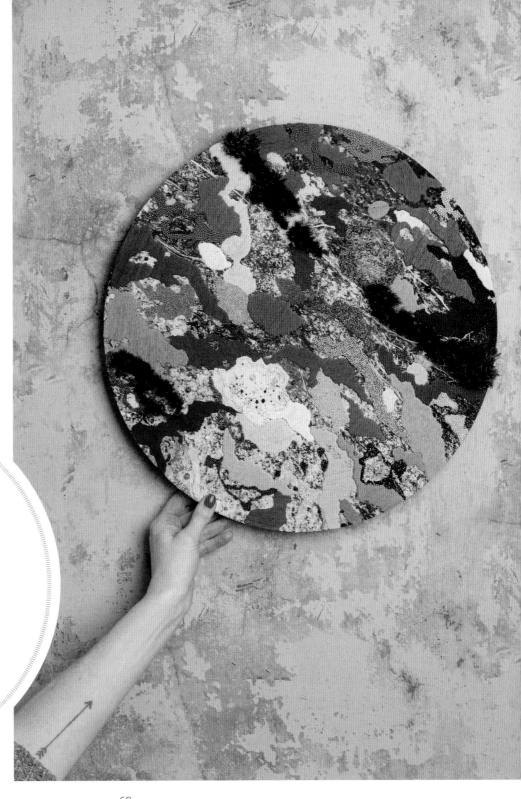

Inspiration

I was lucky enough to spend two full summers living in Zurich and travelling around Switzerland as much as possible, and it was a complete treasure chest of inspiration for my work.

With this hoop, I wanted to focus on the unusual textures that can be found on the side of the mountains, textures that you would easily miss if you weren't paying attention. This particular texture was found while driving up the winding roads of the Furka Pass, and catching a glimpse of oranges and coppers out of the corner of my eye. I quickly made the driver (my patient husband!) pull over to the side, so I could run backwards down the hill, to take as many pictures as possible of the rocks. As it was summer, the glacial ice is constantly melting, so water is always running down the side of the rock face, highlighting colours that you just don't see at other times of the year (I went back in winter and checked!).

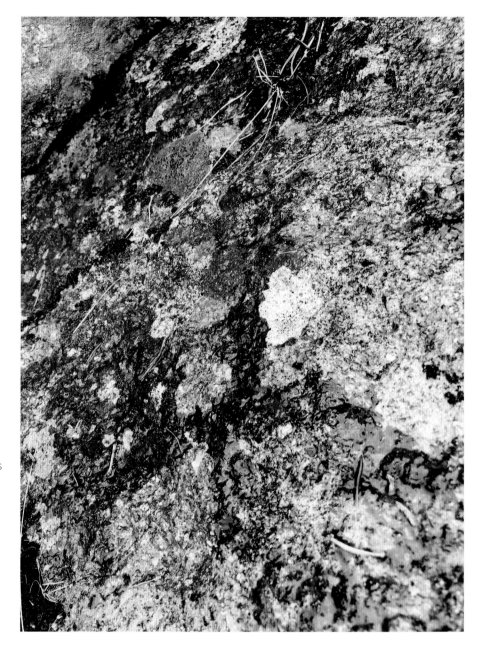

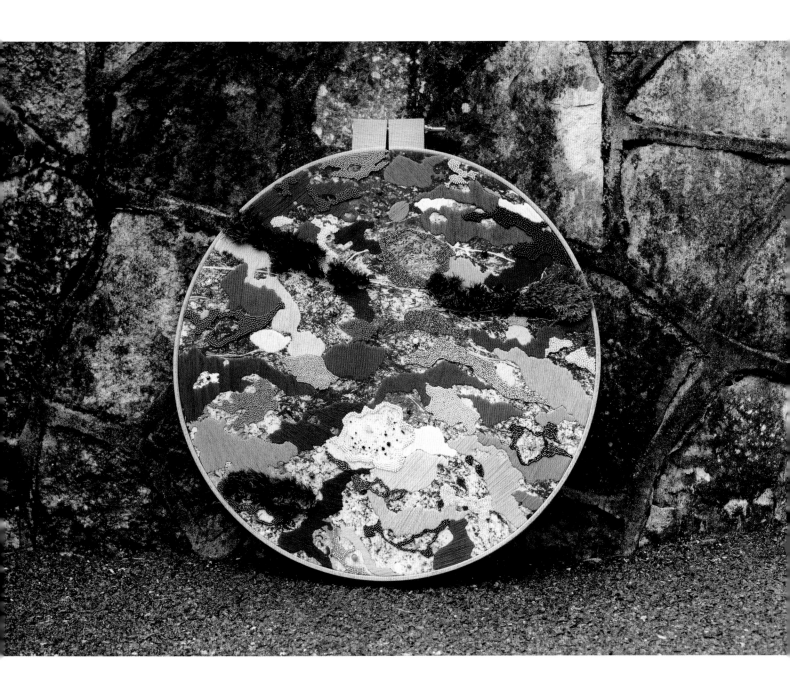

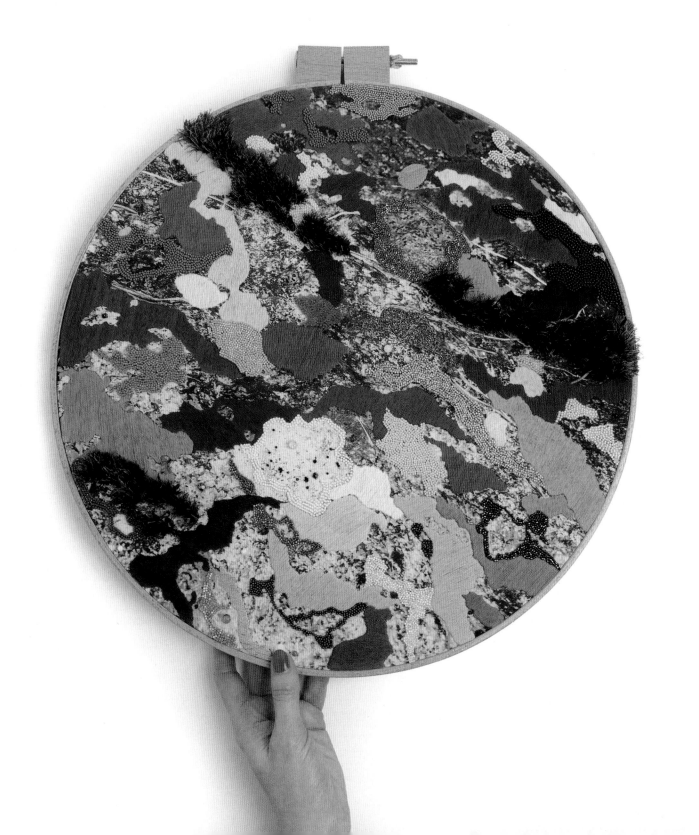

Colour

For me, the pairing of the bright mustard yellows and vibrant oranges creates such a striking contrast to the mossy and green textures you would associate with the Alps, and I found this piece really easy to work through.

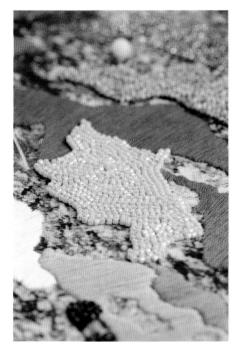

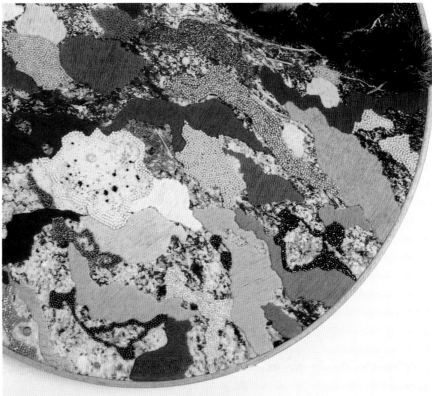

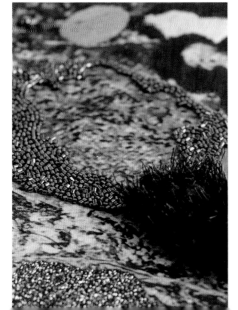

Unlike the hoops in the coastal section, I chose to focus on the range of green tones in small areas of detail rather than using found objects from the environment (no shells to be found in the Alps!).

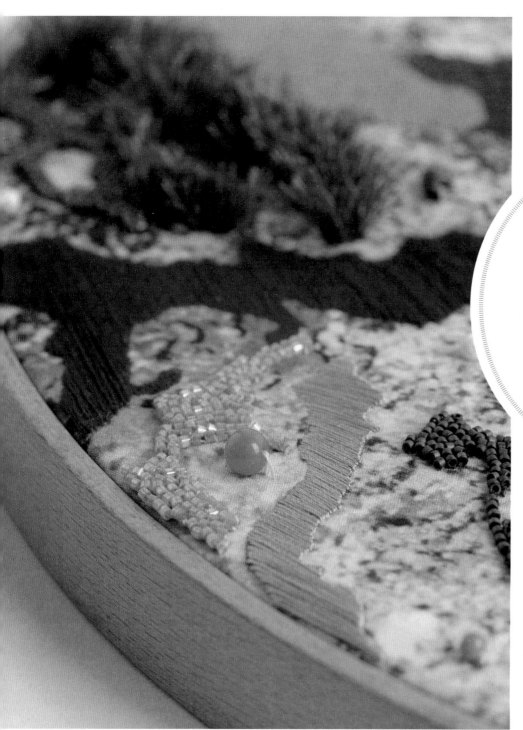

Details

With larger projects, it is important to ensure that even the smallest details are highlighted in the finished piece.

TIP

Although this texture was found in a very specific region of Switzerland, similar textures can be found in areas of higher elevation where there is also a water source (even if that water source is just the rain!). Try exploring during different seasons to see how moisture and sunlight change the colours and shapes you can see in the rocks.

This particular texture provided multiple opportunities to display some of my favourite semi-precious stone beads to add small yet significant pops of colour to balance the overall composition. This natural jade stone bead was perfect for this section of the hoop, and was a one-off addition as I only had one in my collection.

Since the texture was found somewhat by accident at the side of a mountain road, I wanted to pay homage to the exact moment in time that I photographed it. I chose a lot of lustrous or iridescent Miyuki beads to demonstrate how the rocks glistened as the melting glacial water flowed over them. This contrasts well with the matte finish of the thread to represent the areas of the rock face that escaped the water. It may seem like a small distinction, but for me it is a deeply personal detail that I feel enhances the overall effect of the finished hoop.

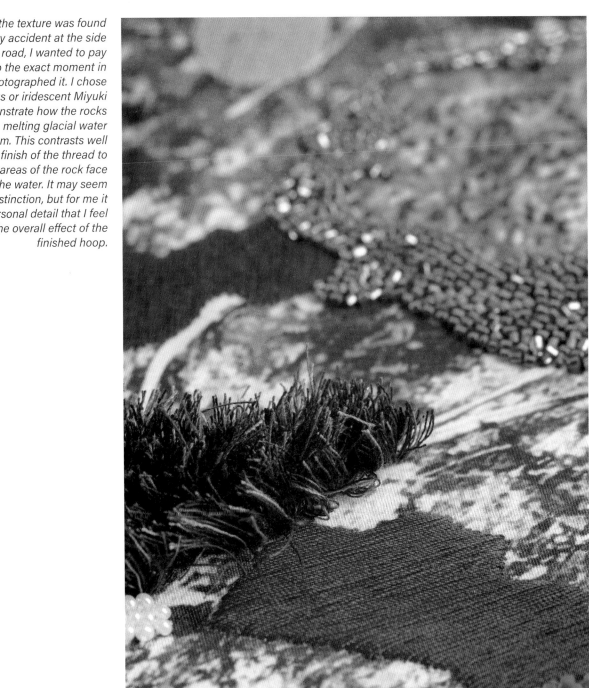

ALPINE 2

During my time in Switzerland I was lucky enough to visit the Rhône Glacier,
which is one of my all-time favourite places to photograph texture.
This is an important piece for me for many reasons, but mostly because
I know the chances of me getting to visit the glacier again are slim, as it is
receding at an alarming rate, so this acts as a time capsule of how it looked
in that moment for me to always remember it.

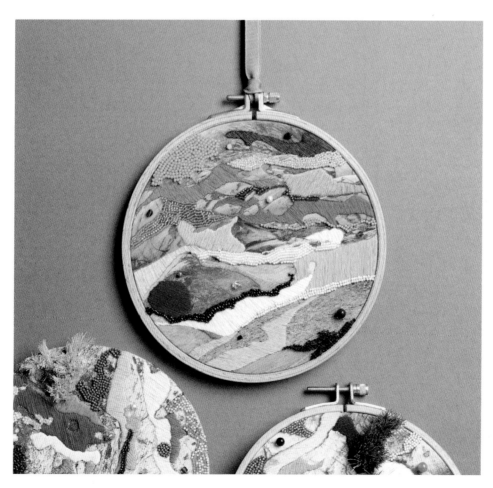

YOU WILL NEED

· 15.25cm (6in)
embroidery hoop
· Printed fabric of your choice
· A selection of embroidery
threads, needles and scissors
· A mixture of small beads,
as well as larger ones for
adding details

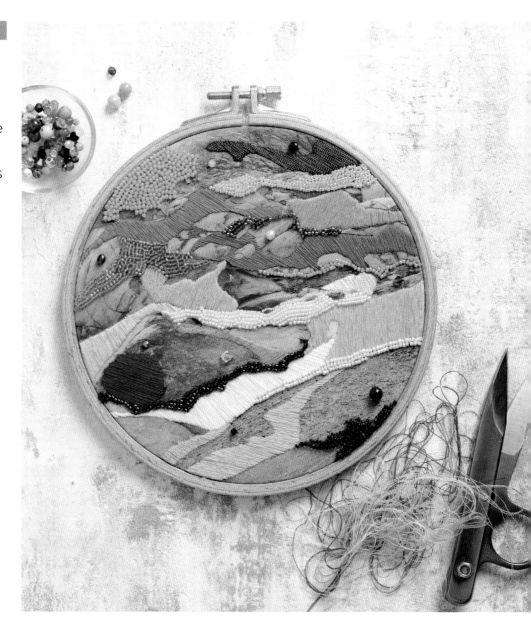

Inspiration

The sheer variety of blues and greys meant that at times the rocks and water were indistinguishable from each other, and I could already imagine how I wanted the final hoop to look.

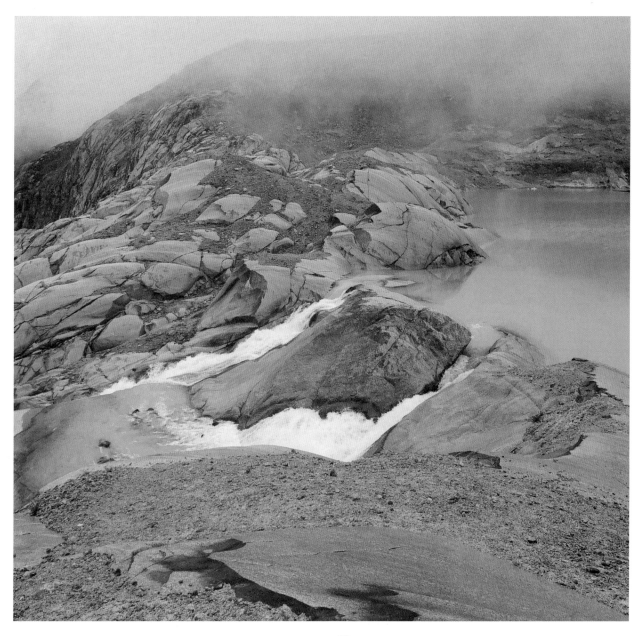

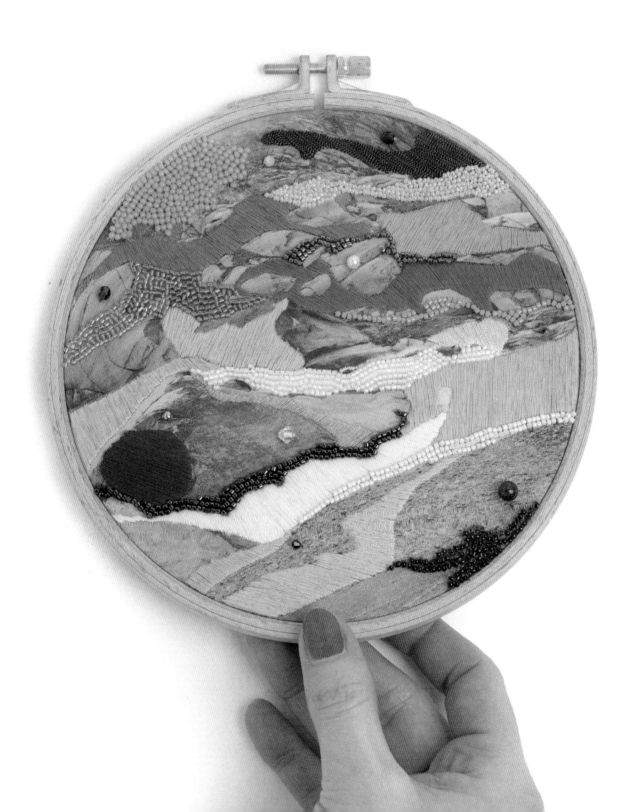

Details

I spent a long time collating all of the different shades of blue thread I own to make sure I was matching them as closely as possible. This is often how I decide whether to use thread or beading within a particular section – I look at which I have the best colour match for.

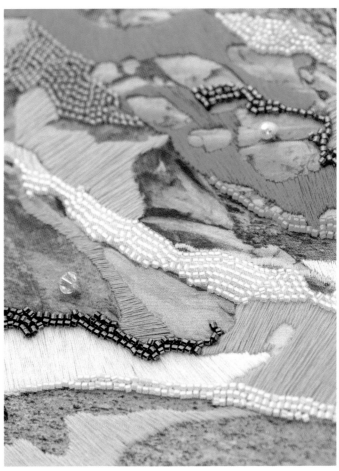

For the areas of white beads, I opted for an almost translucent Miyuki bead to try and convey the semi-transparent feel of the ice.

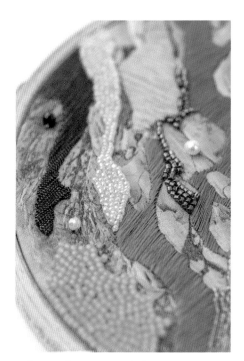

I also used a series of darker blue threads along with iridescent black beads to offer a sense of depth into the composition. To be honest, it was difficult to really demonstrate the scale of the glacier in a smaller hoop, which means I am probably going to have to recreate this as a much larger hoop in the future...

Similar to Alpine 1, I opted to exclude any found objects from the environment where I sourced the texture, as I wanted to keep the ethereal feel of the landscape without giving any contextual clues about where it could be based.

ALPINE 3

For my third Alpine piece I wanted to pay particular attention to the range of colours you can find in the rocks, as purple isn't a colour you automatically associate with the Alps.

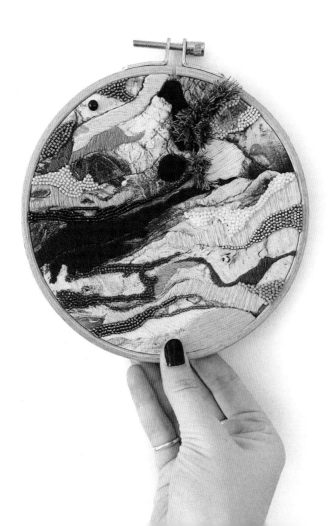

YOU WILL NEED

- 15.25cm (6in) embroidery hoop
- Printed fabric of your choice
- A selection of embroidery threads, needles and scissors
- A mixture of small beads, as well as larger ones for adding details

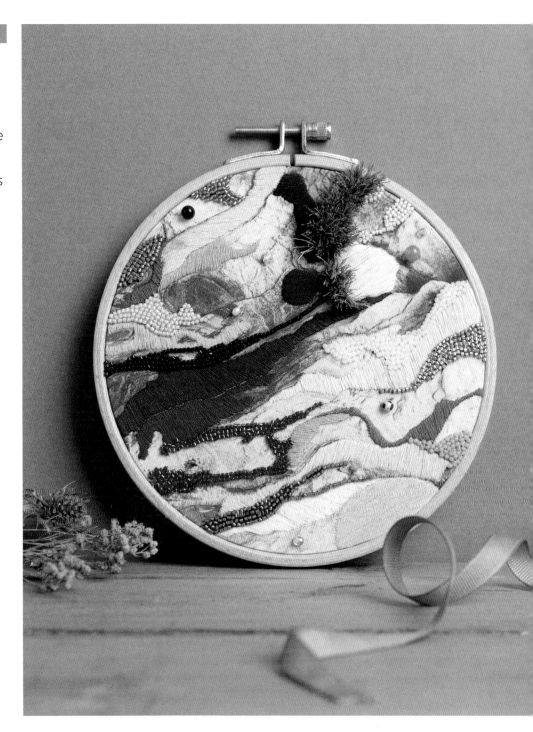

Colour

Since I take the majority of my texture photographs with my camera phone, sometimes what my eyes see and what is actually captured on screen can vary quite a bit. With the images I captured of the rocks, I spent a while experimenting with increasing and decreasing brightness and saturation until I was happy with the finished result shown here. By doing this, I was able to highlight the shades of purple that you can see in this rock formation, giving me a very broad range of colours to work with for this piece.

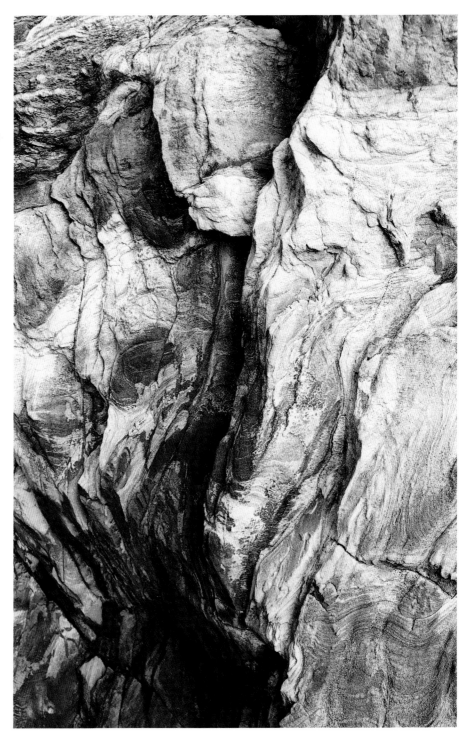

Lines and shapes

I also wanted to draw attention to the linear shapes that are formed within the rocks separating each shade of purple. I tried to translate that onto fabric by stitching sections with similar linear segments, including thinner areas of beading to break up the stitched sections.

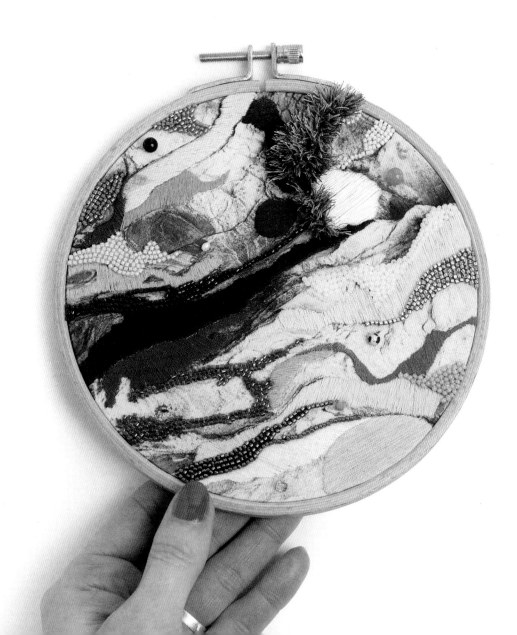

Details

Since this is still a texture that was found on a rock face, I made sure I also included areas of 3D texture as a nod to the different mosses and lichens that I photographed. I used a combination of four to five shades of green thread to add extra depth to the raised areas, and I think it lends a very realistic mossy feel to the piece.

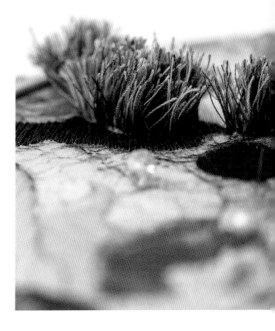

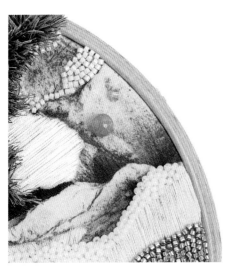

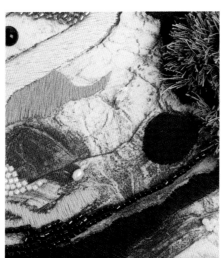

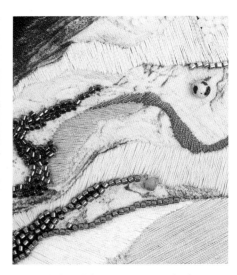

I also intentionally left areas of the fabric free from stitches or beads to highlight how interesting the texture was to begin with, and so that you can still see the surface features and grain of the rocks.

The pink bead that you can see in the bottom right of the hoop is a favourite detail for me. It is a symbol that represents the plethora of small and fragile wildflowers you can find on the mountains.

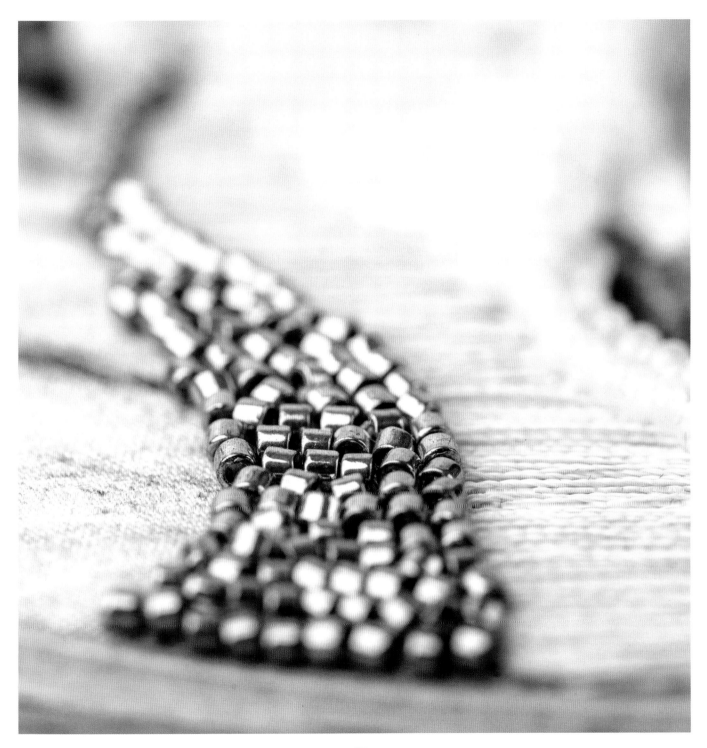

ALPINE 4

The final piece in this Alpine theme is another example of when
I can already see the finished hoop in my mind's eye before I've even
started stitching it.

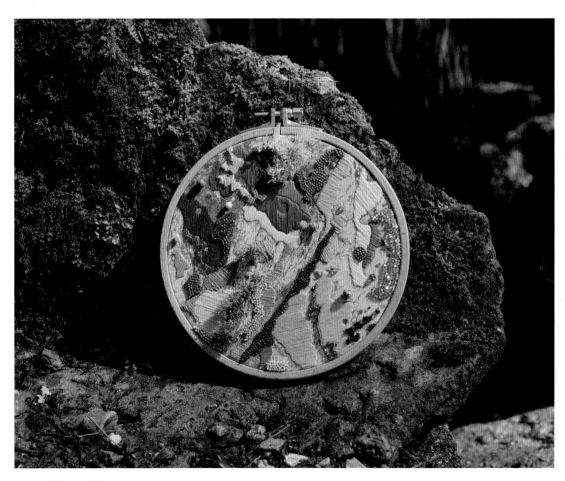

YOU WILL NEED

· 15.25cm (6in)
embroidery hoop
· Printed fabric of your choice
· A selection of embroidery
threads, needles and scissors
· A mixture of small beads,
as well as larger ones for
adding details

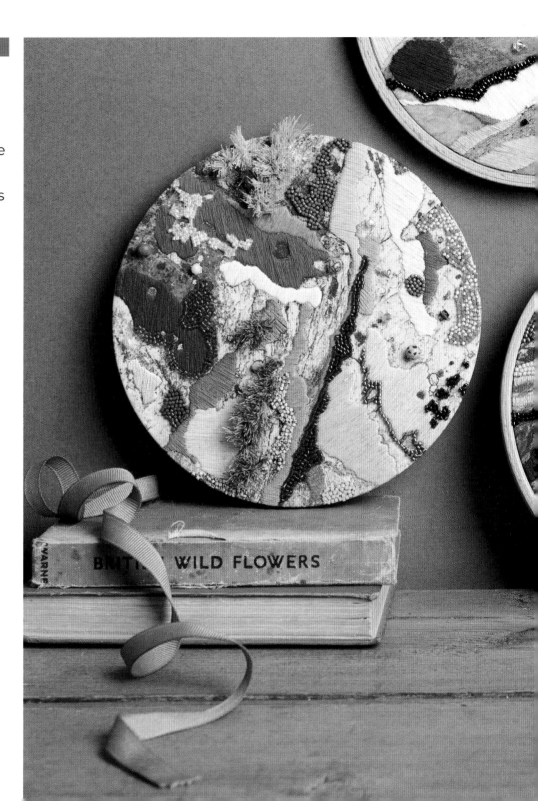

Inspiration

Another example of the variations of rocky textures that can be found within the same area is this texture found on the French side of the Alps on the way down to Lake Annecy. It immediately caught my eye and I spent some time photographing it from different angles before I settled on the composition shown here. This photograph has very minimal editing, I just increased the brightness slightly to overcompensate for a cloudy day. This allowed the orange and peach tones of the rock to really shine through, without being too overpowering.

It was the sections of black dots on these rocks, presumably caused by a type of lichen or fungus growth, that caught my eye the most. I knew straight away how I would represent them on a finished piece – and I knew exactly which beads I would use to do it.

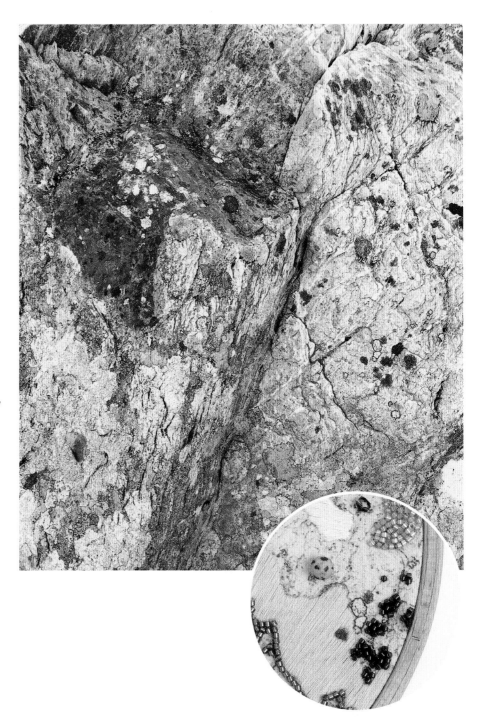

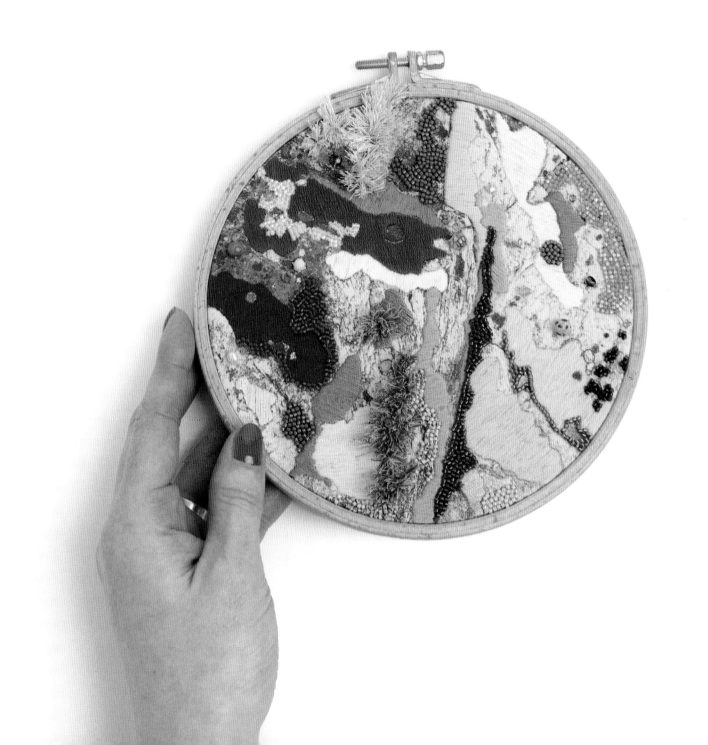

Details

Since there were so many variations of lichens and moss on this particular surface, I used a number of different 3D threads to make sure I was including the biggest colour range possible. With the lighter greens I was able to add the texture while also maintaining the fragile appearance of the lichens.

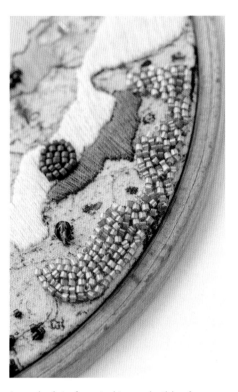

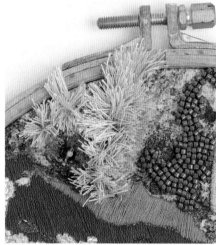

I used a lot of neutral tones in this piece, which isn't the norm for me, but it allowed me to add subtle details with iridescent taupe beads and Dalmatian jasper that add an extra layer to the finished hoop.

TIP

Although not everyone has access to the Alps on their doorstep, a lot of similar textures can be found in local parks and woodland areas. Look for moss and lichens growing on rock surfaces and try photographing them at different times of the day. You'd be surprised what you can find on the side of stone buildings, especially if there are cracks and crevices – things usually find a way to grow in the most unexpected places.

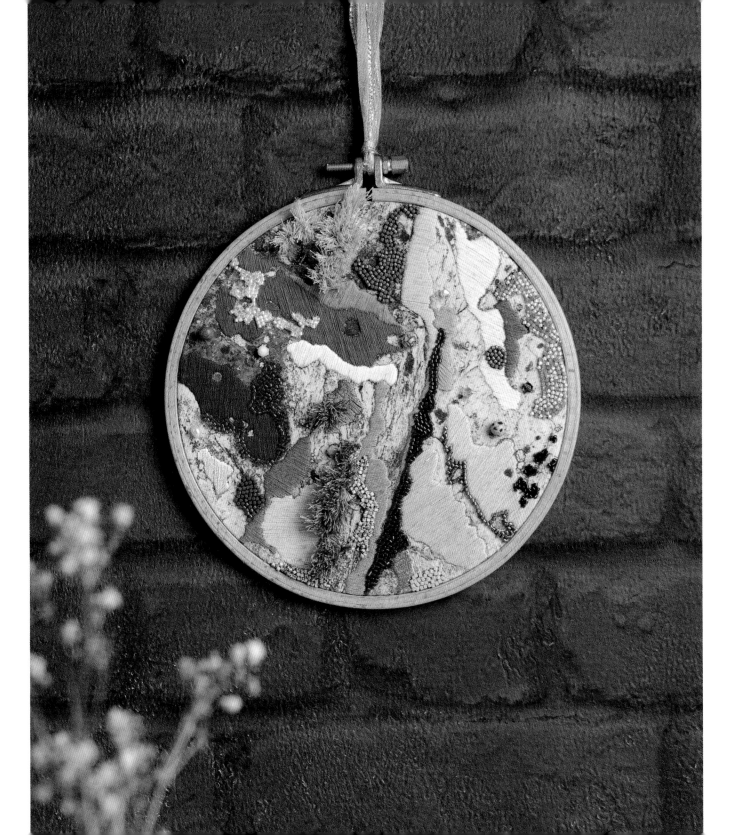

Urban and Man-made

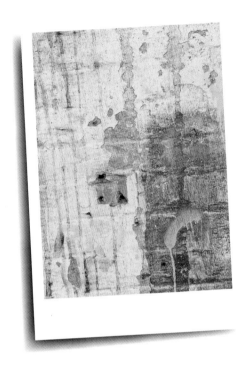

I've been photographing man-made textures since I began my embroidery journey in 2017, but it wasn't until 2020 (and the obvious travel restrictions we all faced) that I started to notice them in more detail. I have included textures that I found in my own home, some of my favourites in industrial spaces from my home town, and textures I've found in some of my favourite places to travel. My hope is that the variation of colours and textures that I have shown will inspire you to find the same excitement in your own settings as I do in mine.

What I love most about working with man-made textures is there is no rule book for the colours that you can use, shapes you can form, or details you can add – I see it as a welcome opportunity to go a bit wild and experiment with the structure of the piece.

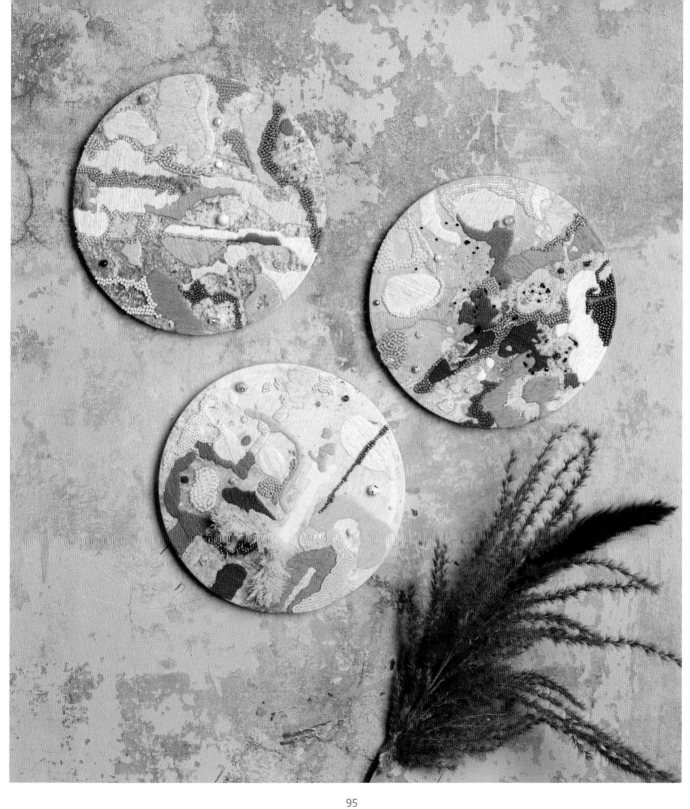

URBAN 1

While the majority of my work is focused around textures in the natural world, I have also steadily been photographing and working with textures found in man-made settings.

This embroidery piece is a reminder that beauty can be found in the most unexpected places. By taking a moment to appreciate the textures and colours that make up our built environment, we can find inspiration in the most unlikely of places and create something truly beautiful.

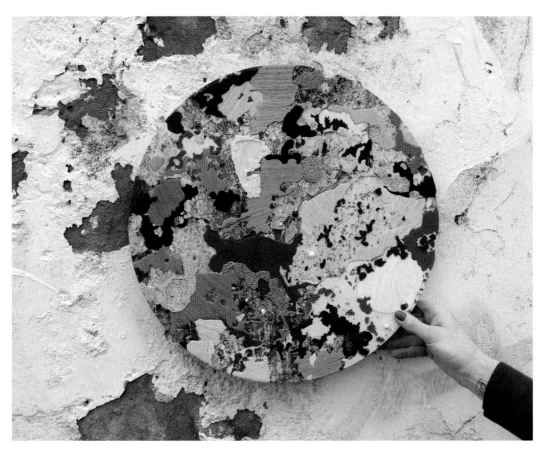

YOU WILL NEED

· 40–45cm (16–18in) embroidery or quilting frame
· Printed fabric of your choice
· A selection of embroidery threads, needles and scissors
· Embroidery needles to hold thicker thread for the 3D sections
· A mixture of small beads, as well as larger ones for adding details

TIP
Quilting frames work better at keeping a good tension in the hoop at this size.

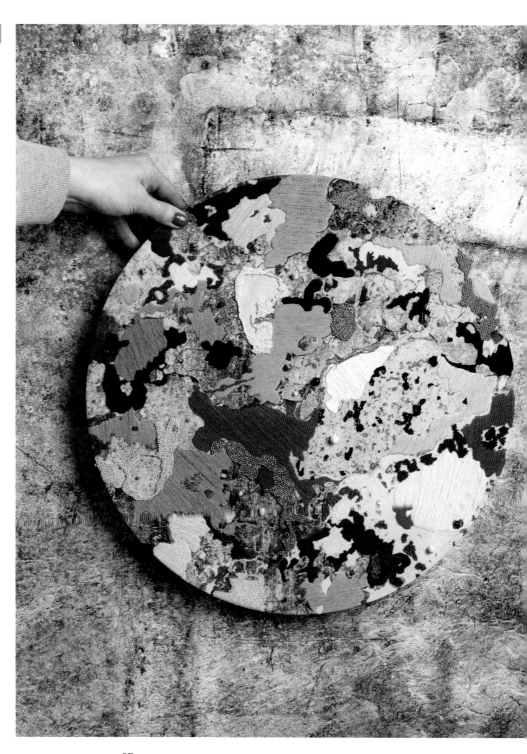

97

Inspiration

Too often, we overlook the beauty that surrounds us in our everyday lives. We pass by buildings, walls and sidewalks without a second glance, never stopping to appreciate the intricate textures and colours that make up our built environment. This project was inspired by a texture found on the side of a building covered in peeling paint in Porto, Portugal.

The colours of the paint on this Portuguese building stood out to me, as they seemed to have been put there purposefully, each layer complementing the next, which is not commonplace to see. Together they formed such an interesting composition and this is a texture I've revisited a number of times to create different pieces. This time I wanted to work on a larger scale to fully explore the details that are present on the surface of the wall.

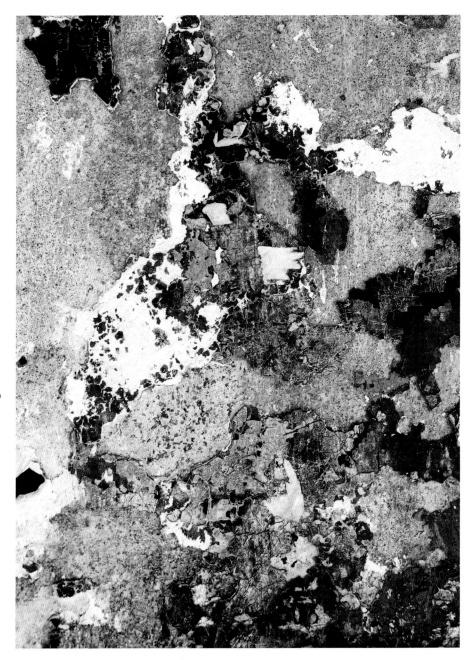

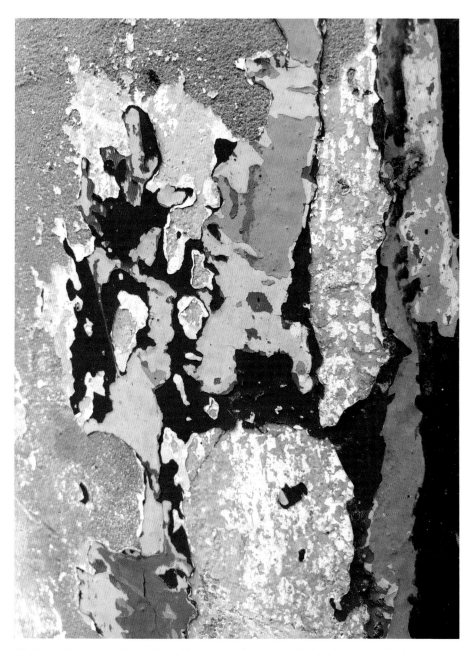

My favourite aspect of working with man-made textures is that there is no limit to the interesting surfaces available. I've photographed graffiti, peeling paint, engraved surfaces, and even patina on metal surfaces to create the basis for embroideries.

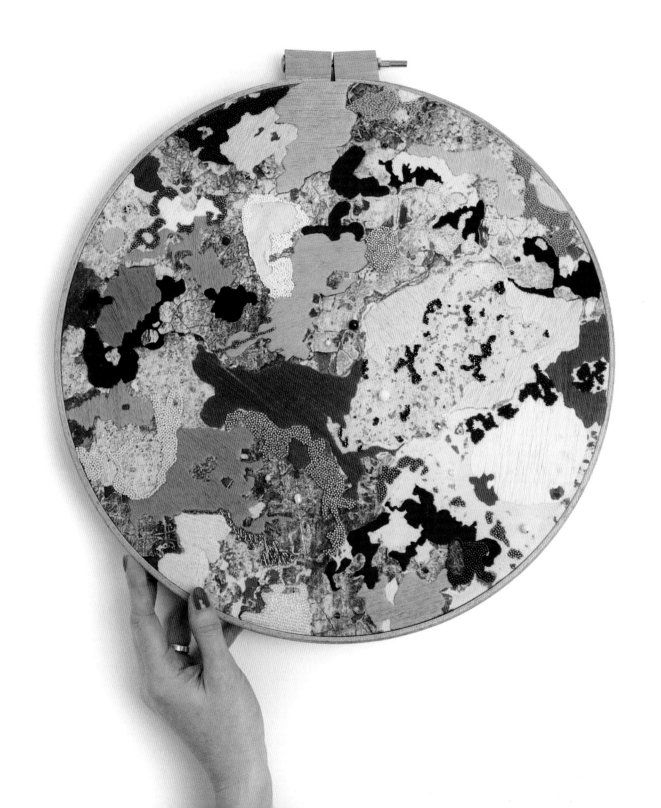

Colour

I had free rein with the range of colours I could use, so I spent plenty of time selecting the right pinks and peaches to use for this particular hoop. Although I had a lot of freedom with the colour palette, the key thing is to keep a balanced composition. With this particular texture, half of the work was already done for me as the colours of the peeling paint complemented each other so perfectly. However, I still had to make sure that it was well translated into the bold palette I chose.

I took the opportunity to use some of my favourite neon shades of pink which don't feature too regularly in my work.

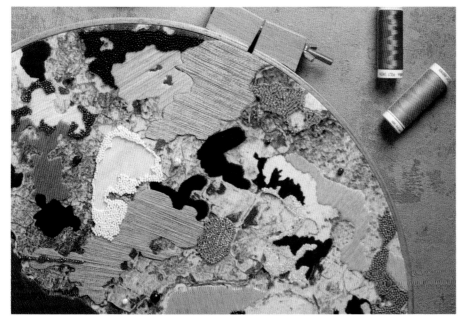

As I don't tend to use a lot of 3D stitches in my pieces inspired by man-made textures, I use different types of embroidery thread to add depth to these pieces. You'll see I have used a combination of matte cotton threads, much shinier polyester threads that are vibrant and catch the light at different angles, along with metallic Sulky threads that almost look like areas of stained glass. I encourage you to try working with many different thread types in your pieces. Go slowly – they can be tricky to work with and take a lot of patience.

I used a couple of very subtly different shades of white threads and areas of seed beads to balance out the pinks and purples. I often use glow in the dark threads (see the area of white satin stitch above) because they come in shades that you can't find in regular thread. It's fun to turn off the lights to see which sections glow!

Details

I use negative space as a tool to highlight the natural beauty found in a lot of the textures I photograph. With this piece, because of the scale, I was able to leave quite large areas free from stitching or beads to show off the rustic beauty of the surface.

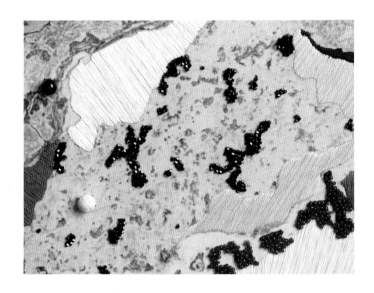

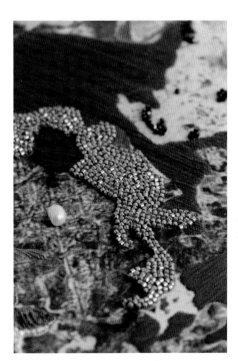

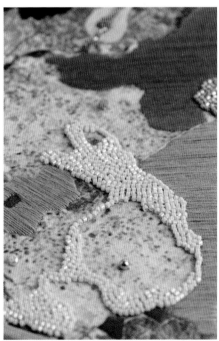

In other places, I introduced many different finishes with the beads I chose, including a lot of small metallic or pearlescent beads to add pops of detail to balance the overall composition. I think this lends an industrial feel to the overall finished piece.

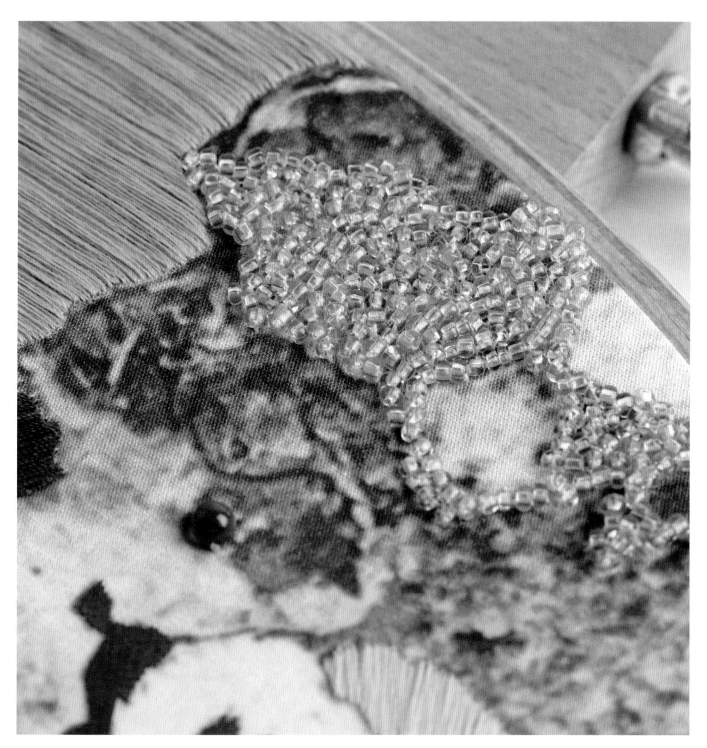

URBAN 2

One thing that the pandemic taught me, among other things, is how heavily I relied on my ability to travel to find textures to inform my work. In the height of 2020 when we were all stuck inside apart from one allocated outdoor walk a day, I challenged myself to find textures in my immediate environment that I could use for embroidery. What followed was a completely new appreciation for the textures around me in any environment.

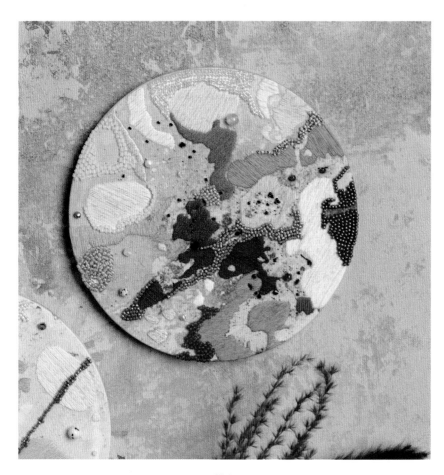

YOU WILL NEED

· 15.25cm (6in) embroidery hoop
· Printed fabric of your choice
· A selection of embroidery threads, needles and scissors
· A mixture of small beads, as well as larger ones for adding details
· A good sense of humour!

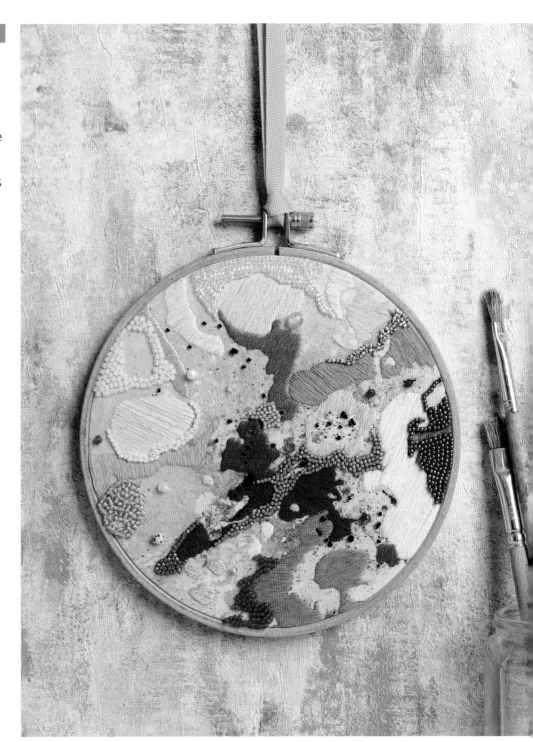

Inspiration

This new outlook when it came to textures led to this project, which was inspired by the photograph shown here of a dirty and paint-stained utility sink in my home! After weeks of trying to get it clean by various means, I ended up taking a picture, and after a bit of artistic license with the saturation of the photograph, could instantly visualize how the finished hoop would look.

Colour

I wanted to maintain a balance of neutral tones to form
the majority of the colour palette of this piece so that the
vibrant oranges and yellows would shine. I personally love
the contrast between the very delicate soft pale greens
and the almost neon orange beads in the centre, and
I definitely don't think this looks like the bottom of a sink!

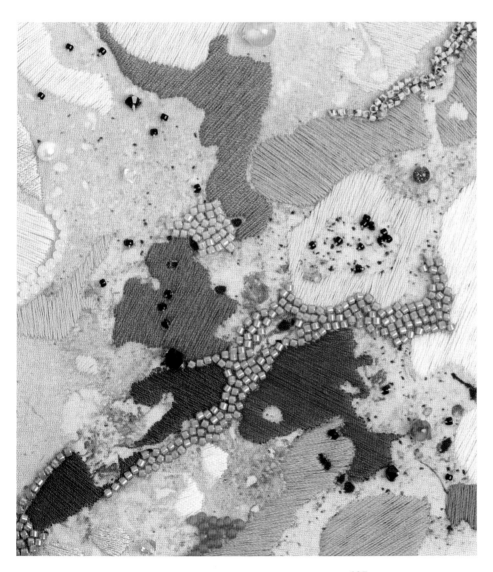

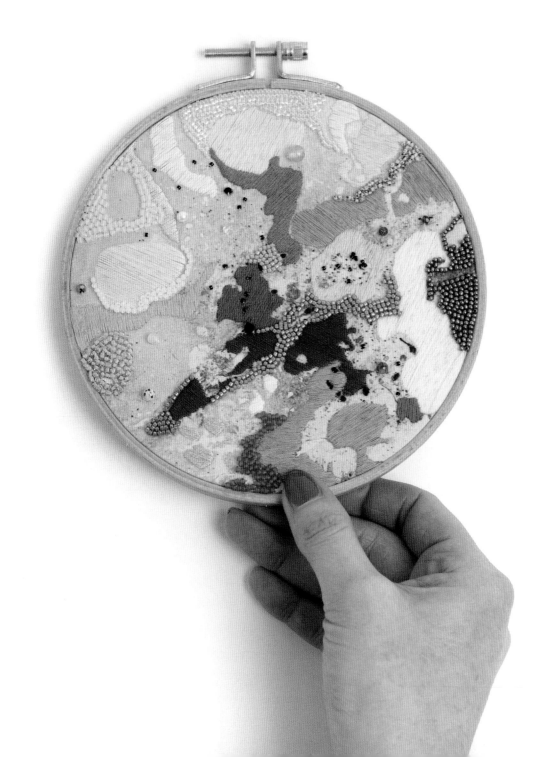

Details

Similar to Alpine 4, the larger dark spots stood out to me and I could easily imagine how to represent them with black Swarovski beads. I chose to use smaller matte seed beads for the tiny specks.

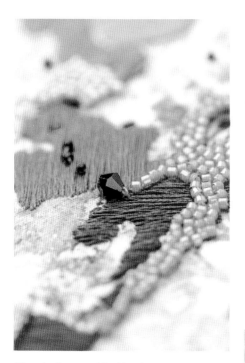

The challenge with this piece was to try and capture the sense of chaos and movement within the paint splatters. There is clearly a good number of years' worth of paint on the bottom of the sink, all from different times and for different reasons, and I was keen to try and communicate that sense of bedlam. One way I tried to incorporate this was by overlapping the black beads on top of the deep orange and tangerine areas of thread. To me it feels like these small black flecks have been sprayed on top of the other areas of paint. This was also mirrored with the use of the small Dalmatian jasper bead (image above) and the Picasso-style Miyuki beads (right image). I wanted even the smallest areas of detail to appear messy rather than using only simple black coloured beads.

TIP

Just as I've mentioned how we can often overlook interesting and beautiful textures in our environment, it also takes a while to train yourself to be constantly on the lookout for interesting places. The sink, for example, was a stroke of luck, but that doesn't mean that you can't also find interesting compositions in other places. The next on my list is to explore areas where paint is mixed in hardware stores to see if I can find some more interesting formations.

URBAN 3

Following on from the theme of seeking out interesting textures in your own environment, I discovered this texture inside the Mackie Mayor building in Manchester. Once a bustling market hall that opened in 1858, the site had closed in the early 1990s and was left vacant. When it was redeveloped into a Food Hall in 2017, the original condition of the interior walls was left as-is, keeping years of spray paint, remnants of old posters, and all sorts of markings.

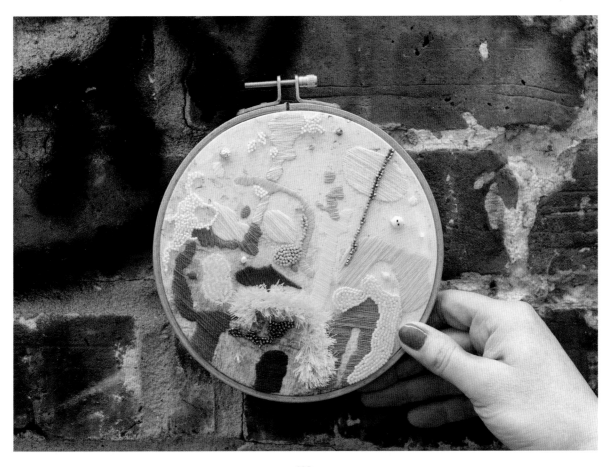

YOU WILL NEED

- 15.25cm (6in) embroidery hoop
- Printed fabric of your choice
- A selection of embroidery threads, needles and scissors
- A mixture of small beads, as well as larger ones for adding details
- The confidence to take weird photographs in public!

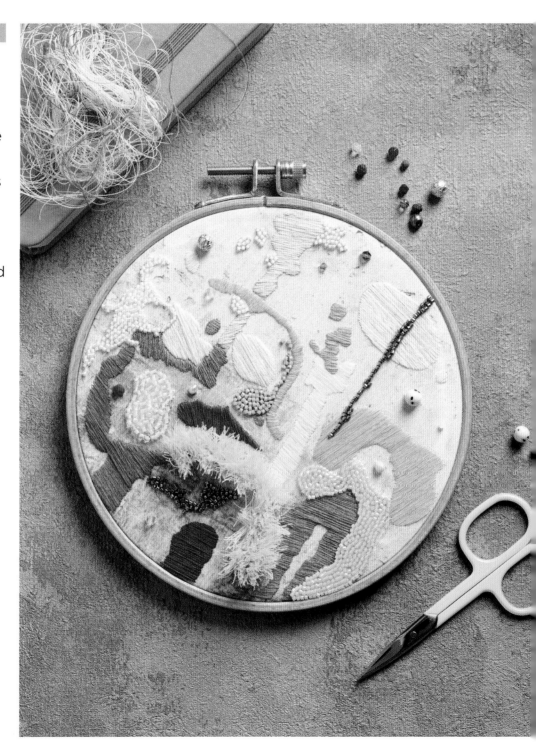

Inspiration

I was absolutely fascinated with the combination of old brickwork alongside the neon spray paint. I quickly (and very embarrassingly!) leaned over a table of people to take as many pictures as I could. This was definitely another example when I was able to see what the finished hoop would look like before I even started stitching it.

Another example of one of my favourite man-made textures is this small section of a bridge found in Central Park, New York, USA. It's a complete joy to find areas of graffiti that look like they have been purposefully colour-matched to their surroundings! Here, the pink, purple and blue paint marks overlap the moss growing in the ashlar sandstone bridge to create its own little hidden rainbow in the middle of the city. This was one of the first examples of graffiti that encouraged me to explore man-made textures in depth.

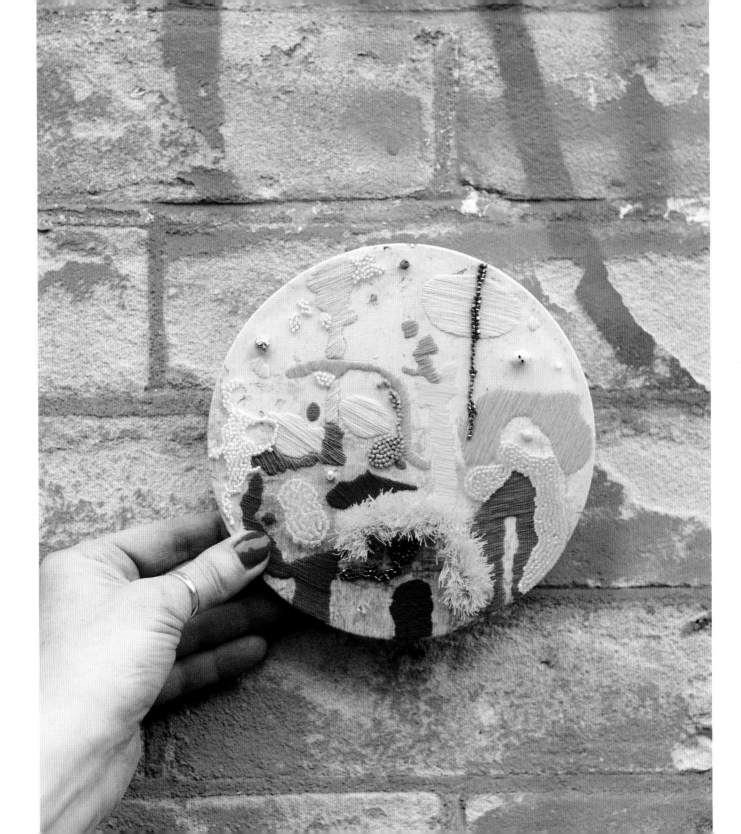

Colour

I knew it would be difficult for me to replicate the texture of the brick walls using thread, so instead I focused on as many of the brighter colours as possible.

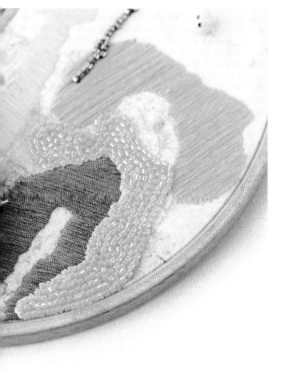

This was a chance for me to use colours that don't tend to feature in my pieces – as you can imagine, neon yellow and green are not the most naturally occurring colours in the environment!

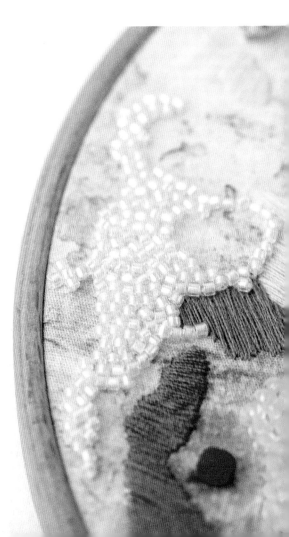

For me, this was the most fun, matching the neon colours to the colours of the graffiti, including using some of my brightest pink beads to highlight the smaller drops of paint.

I used a bit of artistic licence adding 3D texture to the acid green segment, mainly as a nod to my other work inspired by natural textures – as some sort of artificial world landscape.

In keeping with my other pieces borne from man-made textures, I haven't included any shells or found objects, but tried to focus on using visually interesting beads with extra details to add depth to the finished piece.

TIP

When you're searching for your own textures to work with, I think graffiti-based ones will be the most abundant. Try looking for graffiti on old trains and seeing how the paint interacts with the rusted metals, along with stone or concrete buildings local to you.

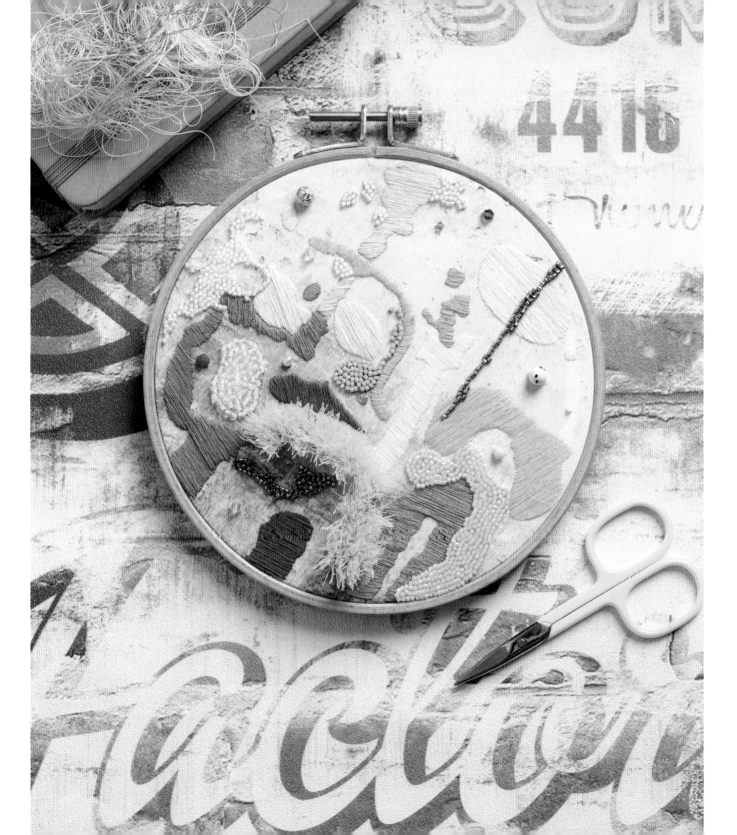

URBAN 4

The texture that inspired this project was found in the Blatvatnik building at
the Tate Modern in London. Formally the Bankside power station that was
opened in 1891, it sat vacant and degrading from 1981 until 2000.
Not long after it opened, the 'cellars' were renovated to use as additional
gallery space, but the interior concrete walls were largely untouched.
Therefore, the walls are covered with years of pen marks, levelling indicators
from the original concrete pouring, chalk numbers and paste from
old notices.

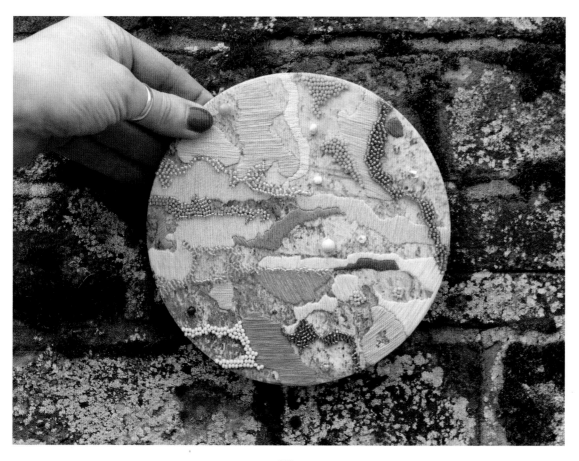

YOU WILL NEED

- 15.25cm (6in) embroidery hoop
- Printed fabric of your choice
- A selection of embroidery threads, needles and scissors
- A mixture of small beads, as well as larger ones for adding details

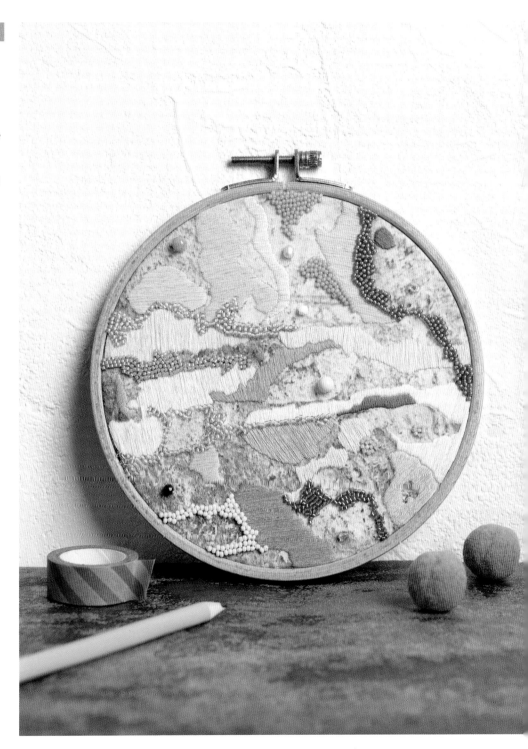

Inspiration

I wanted to capture the essence of space without there being any identifying features of where the place could be.

I wasn't as focused on keeping the colour palette true to real life. I wanted a way to honour places that have been important to me during my artistic development, putting my own spin on areas of the gallery that are often overlooked.

Before I printed the image onto cotton poplin, I dramatically increased the brightness (because it is a very dimly lit gallery space) and boosted the saturation quite a bit so that I could highlight the brightest colours hidden within the texture.

This is the second image I took in my series of exploring textures in the Blatvatnik building of the Tate Modern. Taken not too far away from the first (shown opposite), you can immediately see the complete difference in colours and textures found on the very same walls. Remnants of red paint that have faded over the pitted texture of the concrete walls, along with the bold black pen marks (which I can already visualize in my head in a finished piece) make a really vibrant composition. This is a great example of how endless the possibilities are when photographing textures in man-made settings.

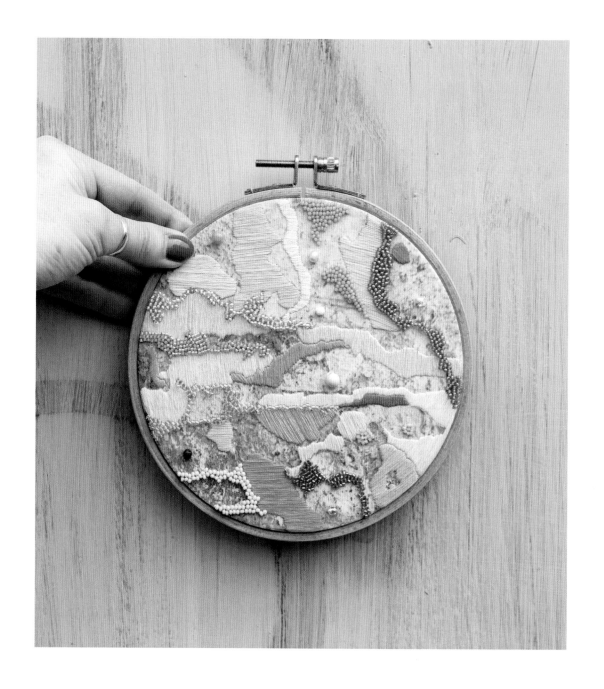

Colour

Even after increasing the saturation, I felt that the colours were still a little less bright than I wanted. I intentionally picked thread colours that were a few shades brighter or more vibrant to add even more contrast to the background texture. I think the best examples are the very neon pinks I've used across the centre of the hoop which form a striking contrast to some of the more pastel blue and purple tones around the edges.

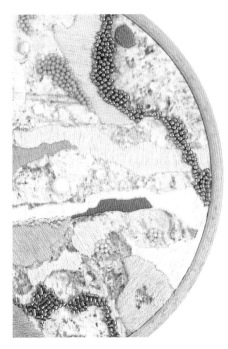

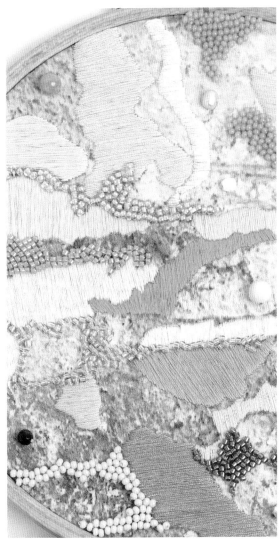

The same applied with the beaded sections – I purposefully chose the brightest pinks and purples from my collection to really make those areas stand out.

Although this is one of my favourite textures from one of my favourite locations, I found this particular texture quite flat when it comes to working with smaller areas of detail (that I would usually highlight with small delicate areas of beading or larger semi-precious stone beads). Because of this I intentionally chose beads that were a little more opulent, such as the lavender freshwater pearl at the top of the hoop, the clear Swarovski crystal to the right, and the spotted white jasper in the middle.

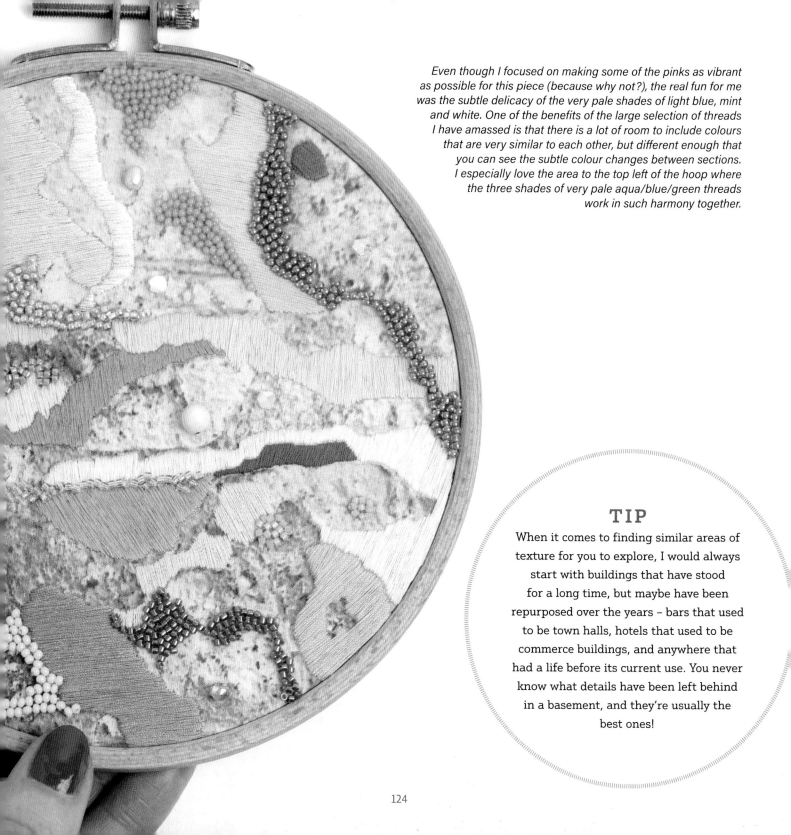

Even though I focused on making some of the pinks as vibrant as possible for this piece (because why not?), the real fun for me was the subtle delicacy of the very pale shades of light blue, mint and white. One of the benefits of the large selection of threads I have amassed is that there is a lot of room to include colours that are very similar to each other, but different enough that you can see the subtle colour changes between sections. I especially love the area to the top left of the hoop where the three shades of very pale aqua/blue/green threads work in such harmony together.

TIP

When it comes to finding similar areas of texture for you to explore, I would always start with buildings that have stood for a long time, but maybe have been repurposed over the years – bars that used to be town halls, hotels that used to be commerce buildings, and anywhere that had a life before its current use. You never know what details have been left behind in a basement, and they're usually the best ones!

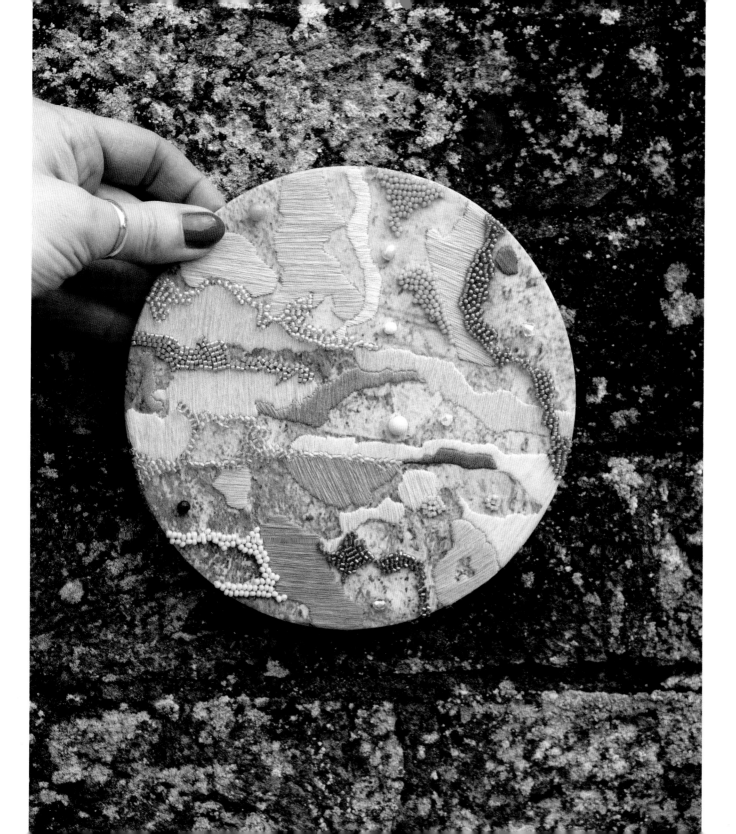

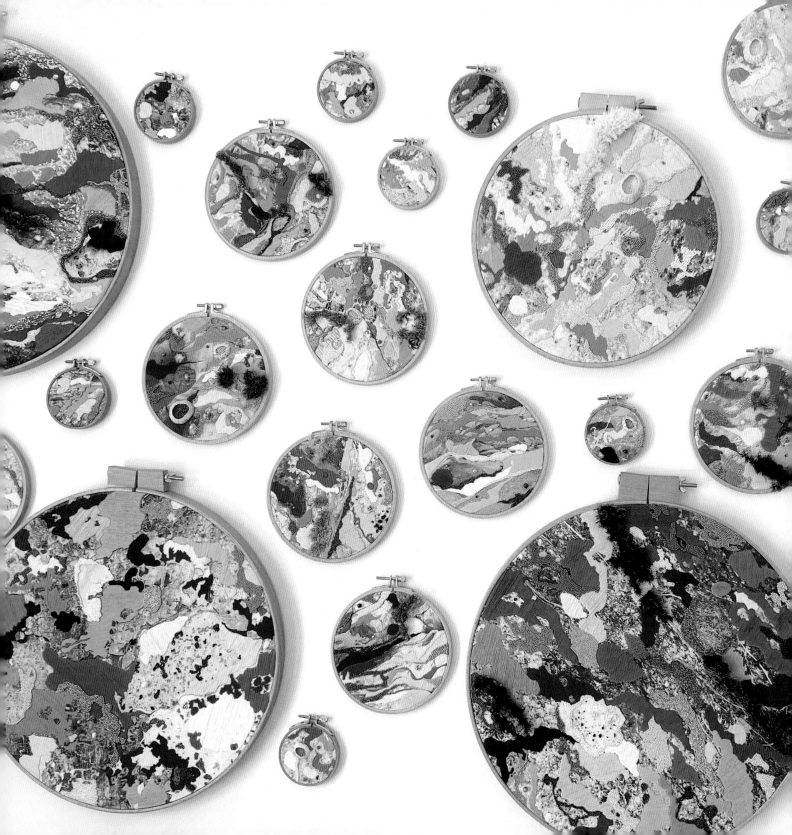

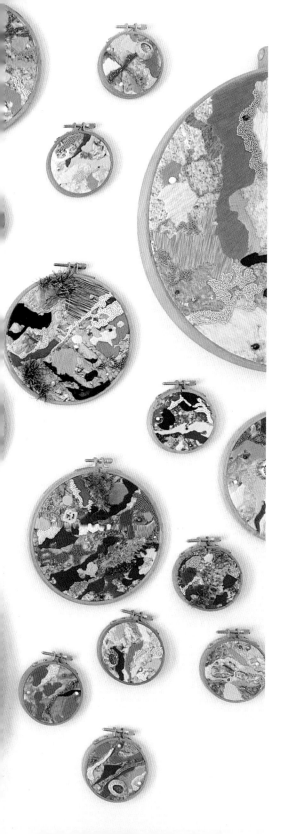

Gallery

I wish I could include every piece I've ever created to truly give you a sense of the variation that is possible with this style of embroidery, but I have tried my best to include some examples of previous work and other locations that have informed my work over the past five years. I hope they encourage you to head out in search of your own inspiration, and remind you that often the best creative starting points can be the most overlooked.

Xantholyta
45cm (18in)
Inspired by a texture found on Rhosneigr Beach, Wales.

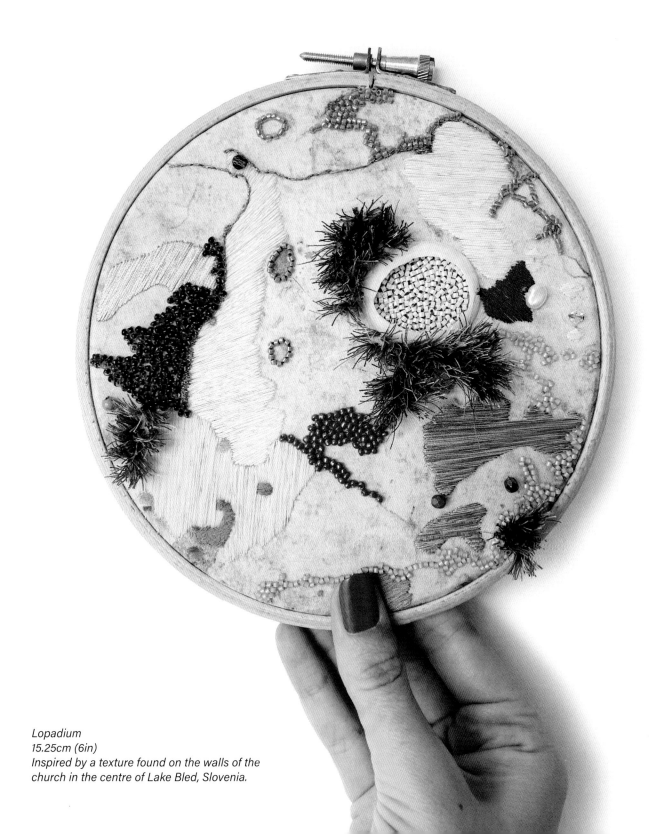

Lopadium
15.25cm (6in)
Inspired by a texture found on the walls of the
church in the centre of Lake Bled, Slovenia.

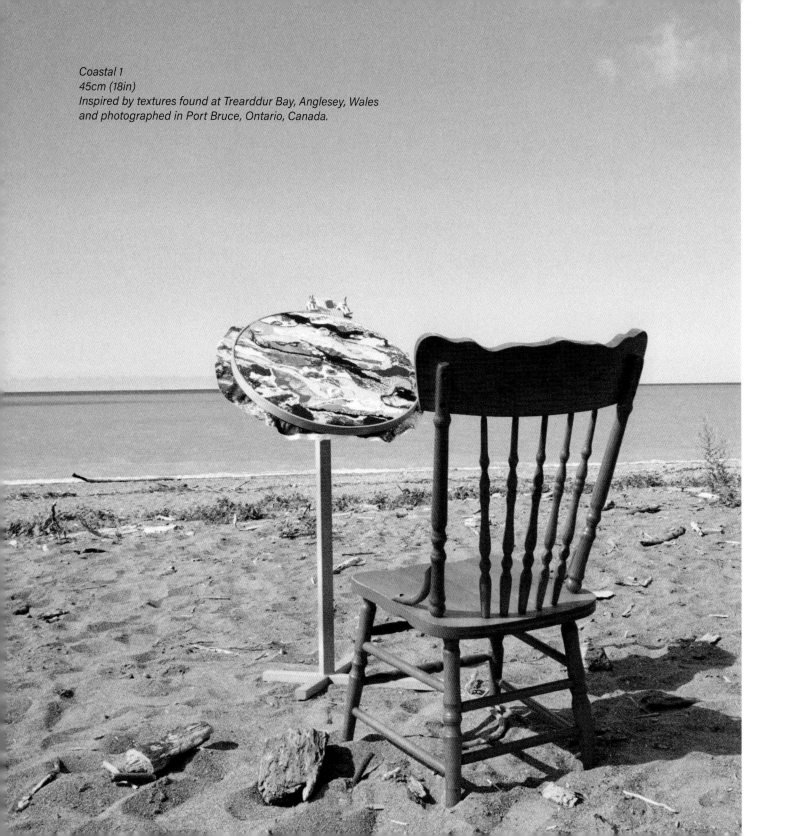

Coastal 1
45cm (18in)
Inspired by textures found at Trearddur Bay, Anglesey, Wales
and photographed in Port Bruce, Ontario, Canada.

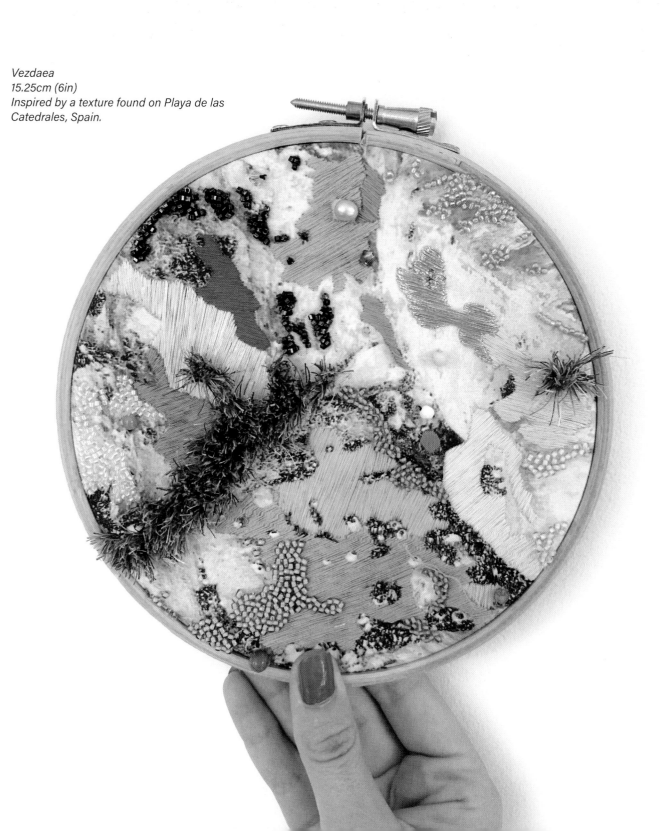

Vezdaea
15.25cm (6in)
Inspired by a texture found on Playa de las Catedrales, Spain.

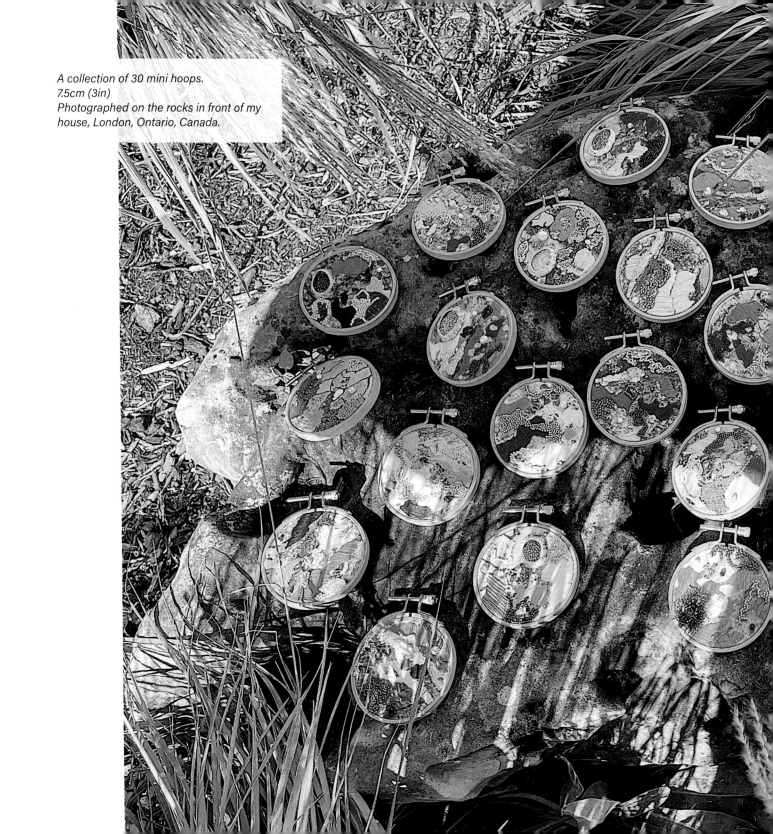

A collection of 30 mini hoops.
7.5cm (3in)
Photographed on the rocks in front of my house, London, Ontario, Canada.

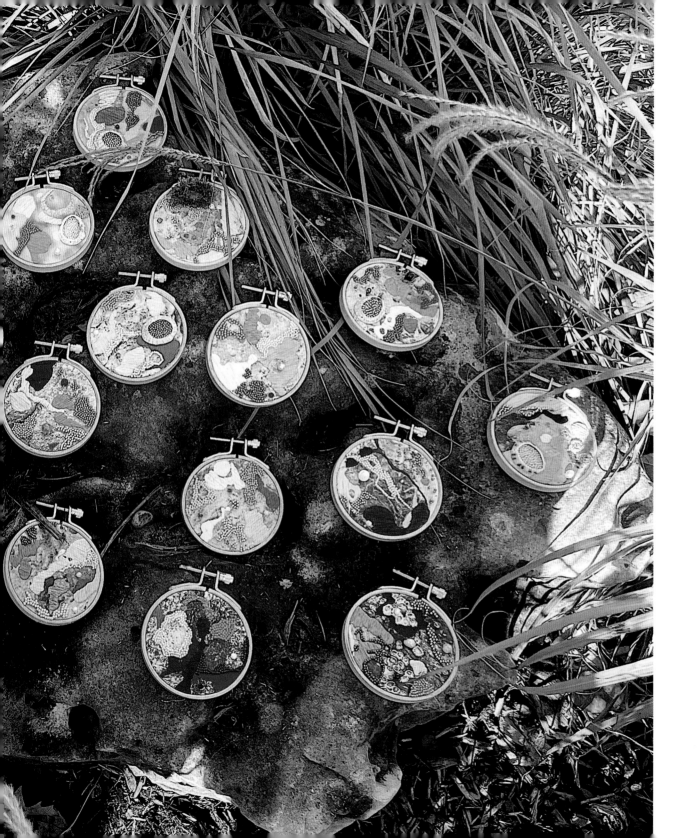

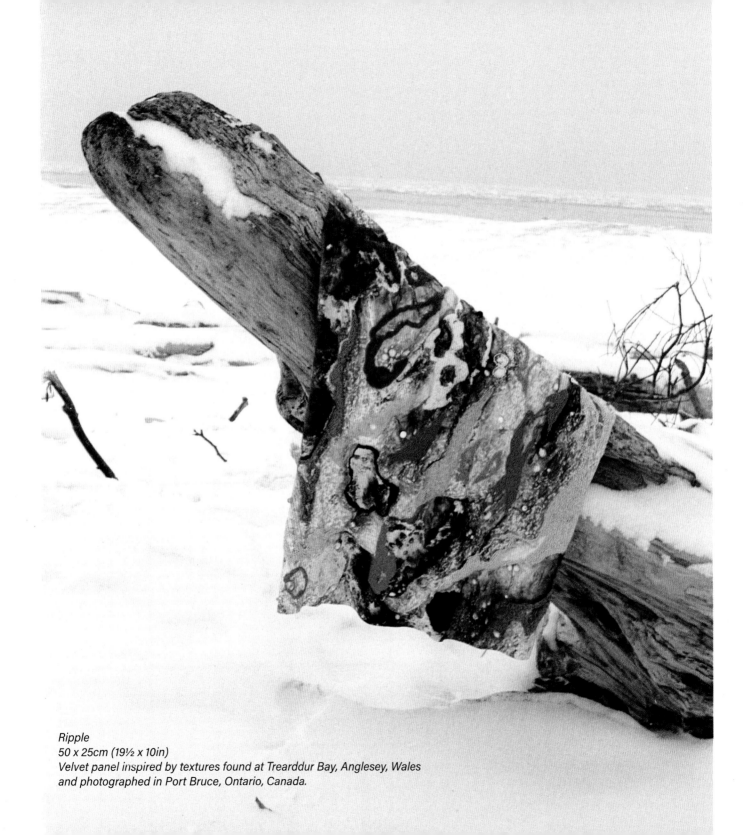

Ripple
50 x 25cm (19½ x 10in)
Velvet panel inspired by textures found at Trearddur Bay, Anglesey, Wales
and photographed in Port Bruce, Ontario, Canada.

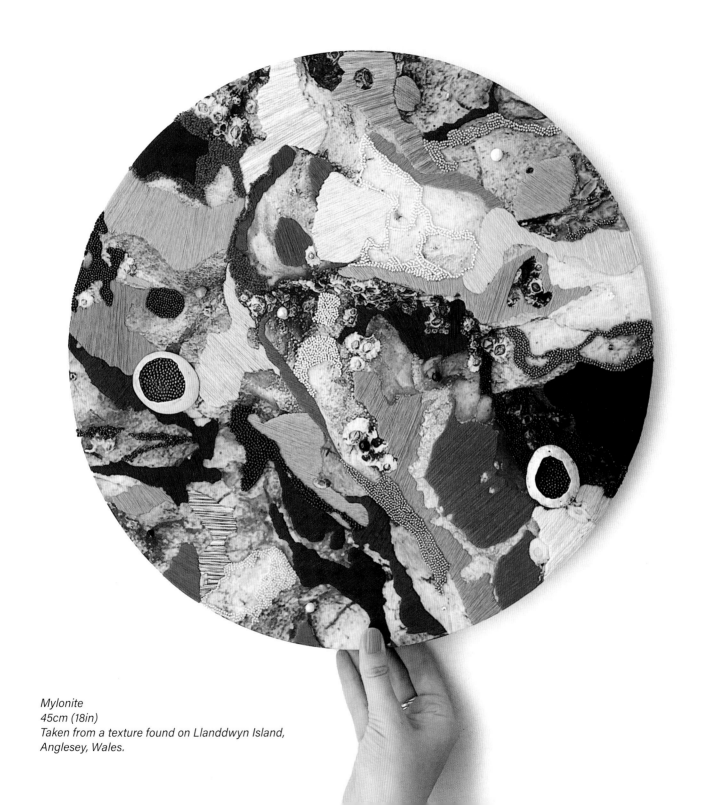

Mylonite
45cm (18in)
Taken from a texture found on Llanddwyn Island,
Anglesey, Wales.

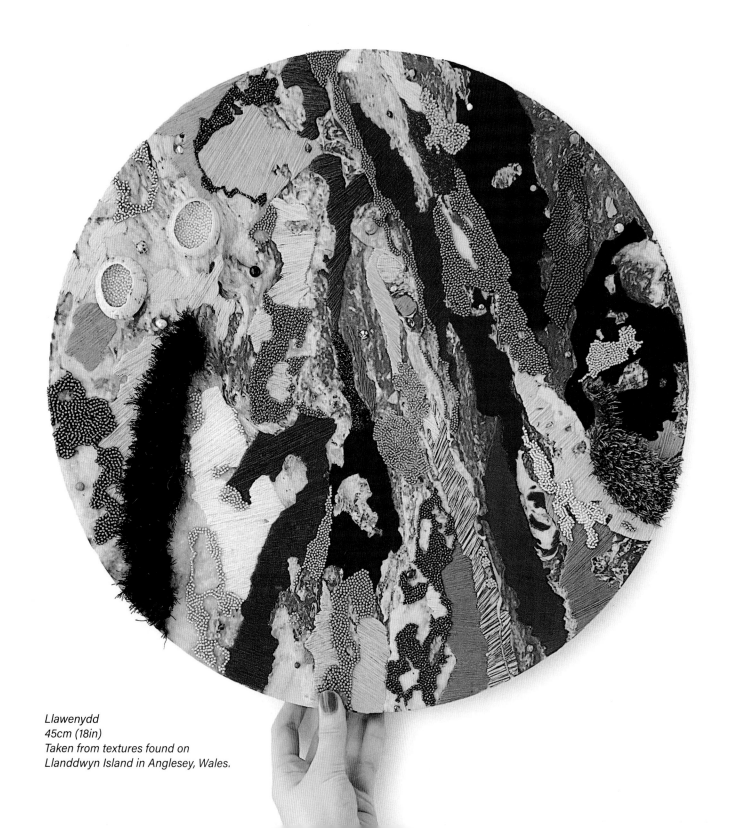

Llawenydd
45cm (18in)
Taken from textures found on
Llanddwyn Island in Anglesey, Wales.

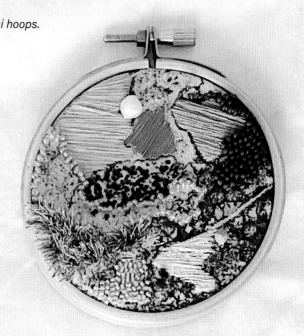
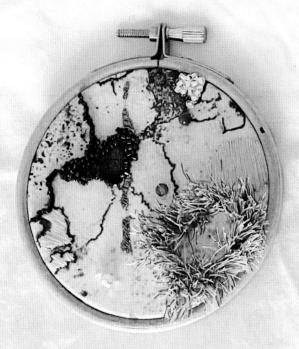
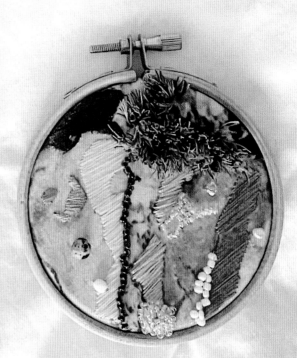

A group of mini hoops.
7.5cm (3in)

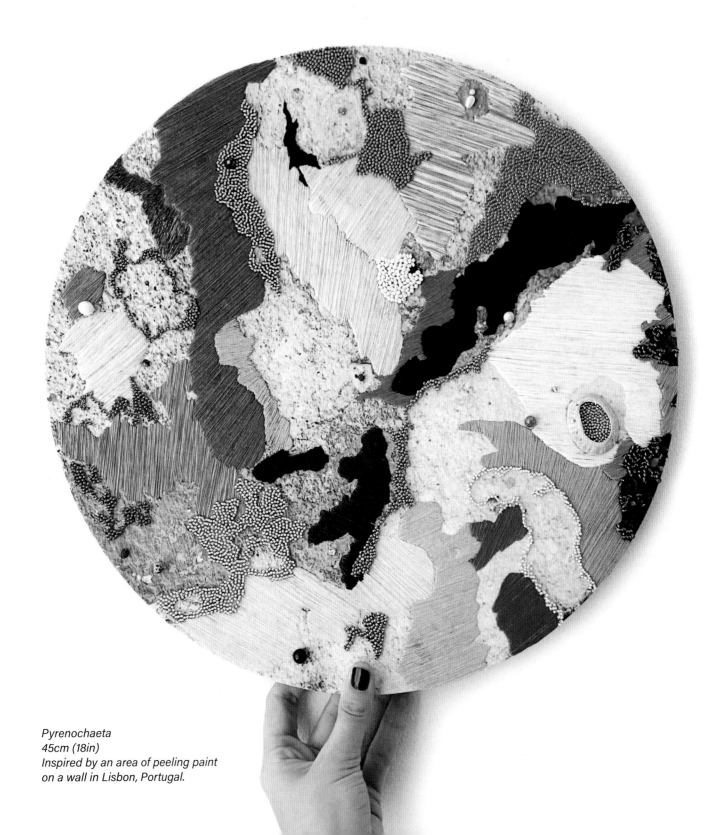

Pyrenochaeta
45cm (18in)
Inspired by an area of peeling paint
on a wall in Lisbon, Portugal.

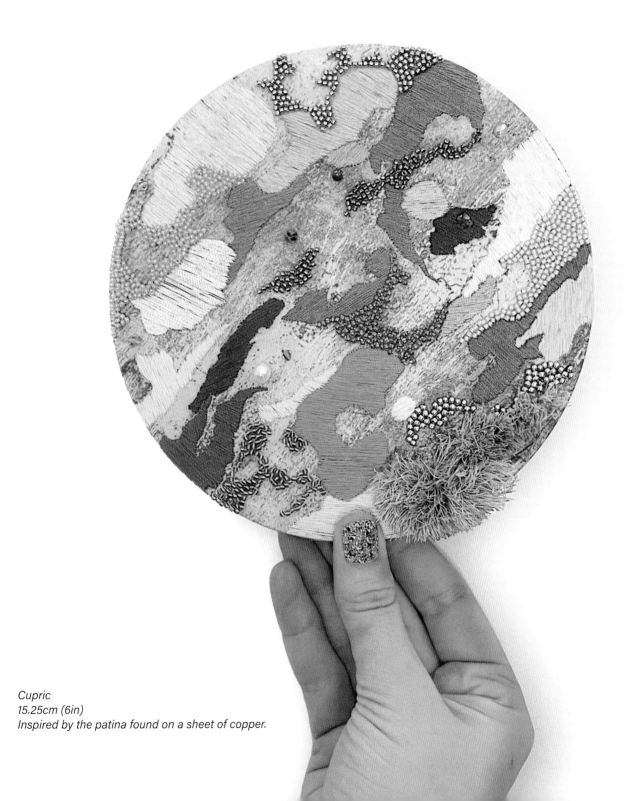

Cupric
15.25cm (6in)
Inspired by the patina found on a sheet of copper.

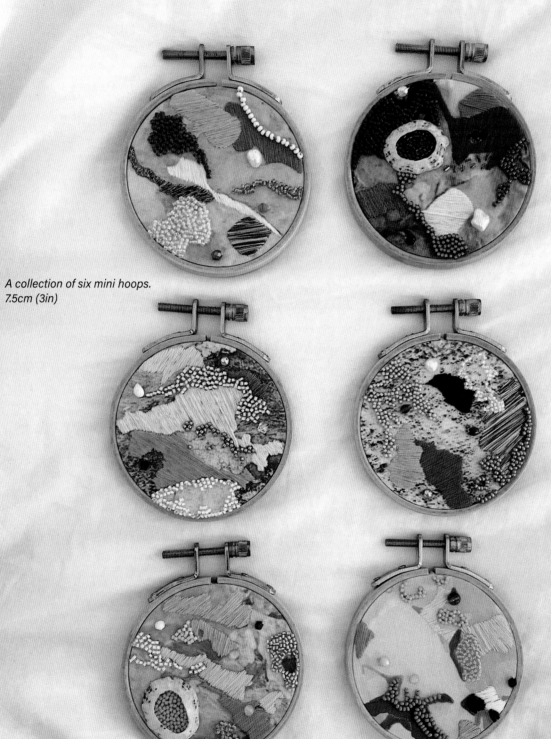

A collection of six mini hoops.
7.5cm (3in)

Ferrous
15.25cm (6in)
Inspired by peeling paint on a public lamppost
in Stretford, Manchester, England.

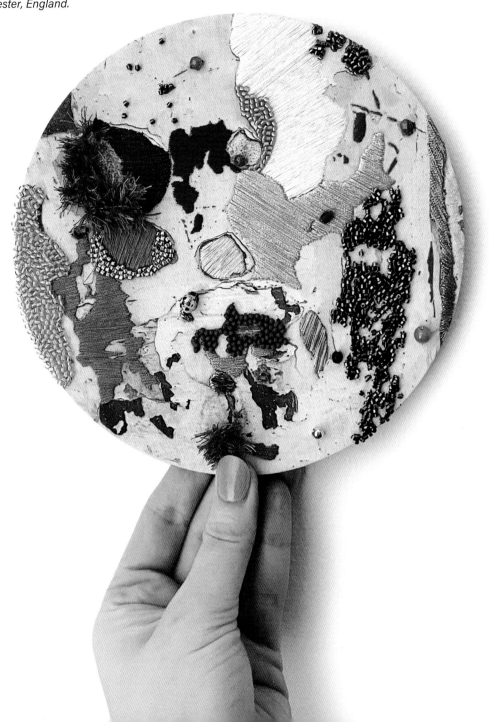

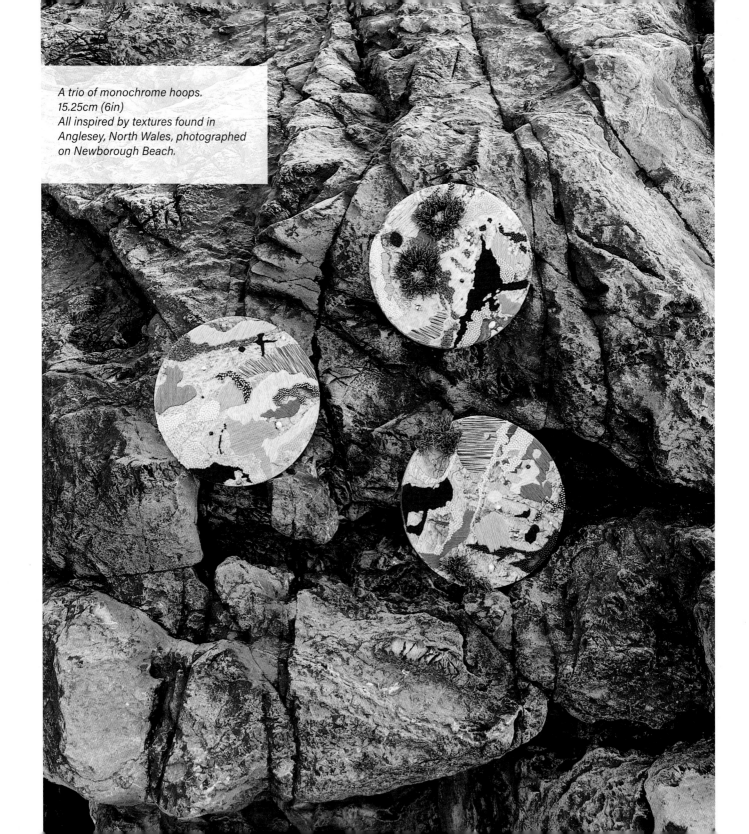

A trio of monochrome hoops.
15.25cm (6in)
All inspired by textures found in
Anglesey, North Wales, photographed
on Newborough Beach.

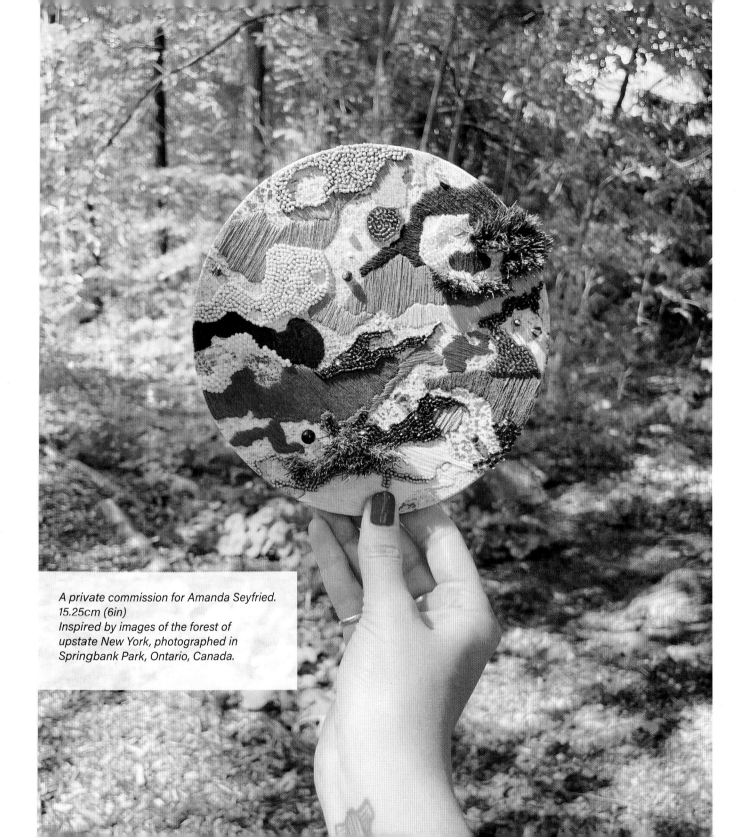

A private commission for Amanda Seyfried.
15.25cm (6in)
Inspired by images of the forest of
upstate New York, photographed in
Springbank Park, Ontario, Canada.

First published in 2024
Search Press Limited
Wellwood, North Farm Road,
Tunbridge Wells, Kent TN2 3DR

Copyright © Search Press Ltd. 2024
Cover photograph by Richard Botelho.
Photographs on pages 10 (bottom), 11 (middle and bottom),
47, 48 (top), 53, 55 (top), 56, 63, 64, 80 (right), 81, 86 (top),
87, 92 (left and right), 109, 115 and 116 by Mark Davison at
Search Press Studios.
Photographs on pages 2, 7, 8, 10 (top), 11 (top), 12, 13, 14, 15
(main), 17–21, 23, 24 (top), 25–29, 32, 36, 44, 52, 60, 61, 66, 70,
78, 84, 90, 94, 98, 99, 106, 113, 120, 121, 126–144 by the author.
All other photographs by Stacy Grant.

Illustrations on pages 22 and 27 by Lauren Heaver.

All rights reserved. No part of this book, text, photographs or
illustrations may be reproduced or transmitted in any form
or by any means by print, photoprint, microfilm, microfiche,
photocopier, video, internet or in any way known or as yet
unknown, or stored in a retrieval system, without written
permission obtained beforehand from Search Press.
Printed in China.

ISBN: 978-1-80092-096-5
ebook ISBN: 978-1-80093-087-2

The Publishers and author can accept no responsibility for
any consequences arising from the information, advice or
instructions given in this publication.

No use of the projects for commercial purposes is permitted
without the prior permission of both author and Publishers.
Readers are permitted to reproduce or copy the projects in
this book only for private and personal study/practice.

Suppliers
If you have difficulty in obtaining any of the materials and
equipment mentioned in this book, then please visit the
Search Press website for details of suppliers:
www.searchpress.com

Templates
Textured prints are available to download free from the
Bookmarked Hub: www.bookmarkedhub.com
Search for this book by title or ISBN: the files can be
found under 'Book Extras'. Membership of the
Bookmarked online community is free.

Available to download is a wide selection of both natural and
man-made textures that I have photographed, to inspire you
to create your own abstract embroidery hoops. I would always
encourage you to go out and explore your environment to find
your own inspiration, but please feel free to download these
and print them onto fabric to experiment with. I have found
that custom fabric printing is the easiest and most cost-effective
way to get the results I want. Here are a few examples of online
fabric printers, but do your own local research:

www.wovenmonkey.com (UK)
www.spoonflower.com (US)
www.contrado.ca (Canada)
www.frankieandswiss.com.au (Australia)

About the author
You are invited to visit the author's website and Instagram:
www.saltstitches.com
@salt_stitches

SEARCH PRESS LIMITED
The world's finest art and craft books

For all our books and catalogues go to
www.searchpress.com

www.searchpressusa.com www.searchpress.com.au

Please note that not all of our books are available in all markets

Follow us @searchpress on:

Ⅱ BOOKMARKED
The Creative Books Hub

from Search Press and
David & Charles

WHY JOIN BOOKMARKED?

Membership of the world's leading
art and craft book community

Free projects, videos
and downloads

Exclusive offers, giveaways
and competitions

Share your makes with the
crafting world

Meet our amazing authors!

www.bookmarkedhub.com

Follow us on:

@bookmarkedhub

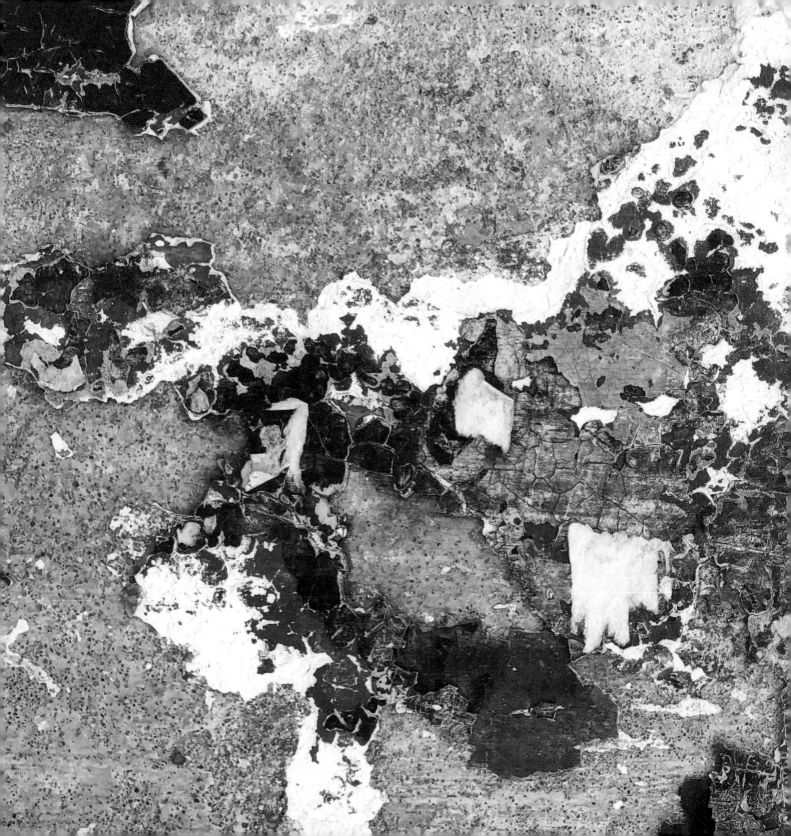